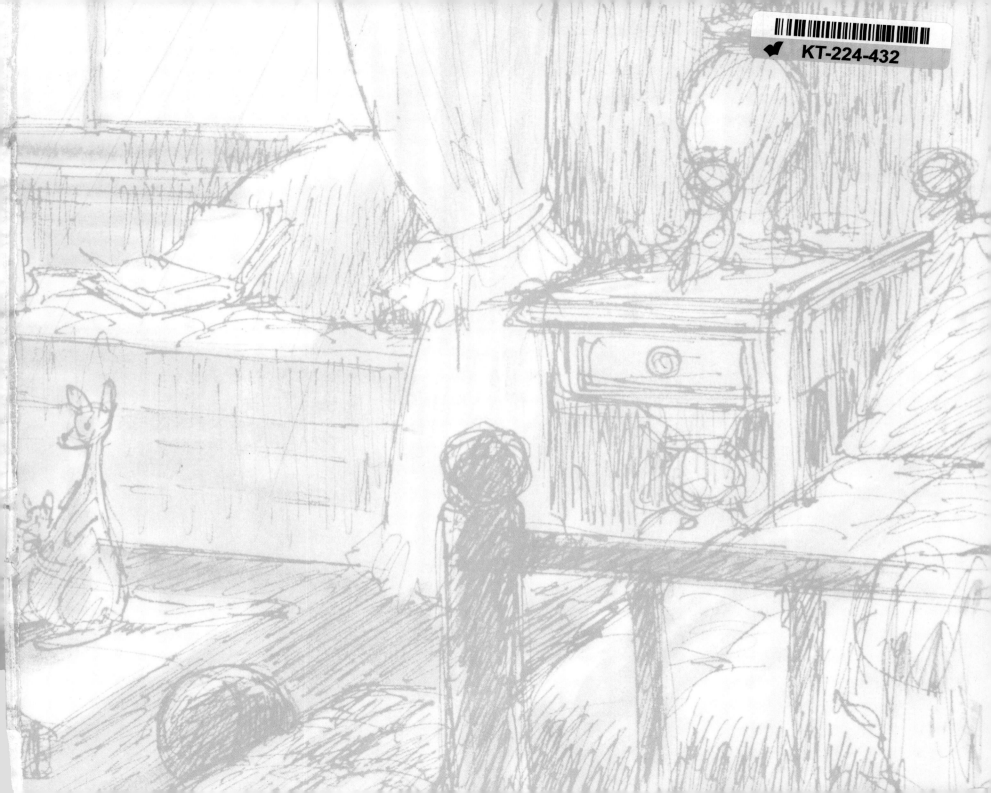

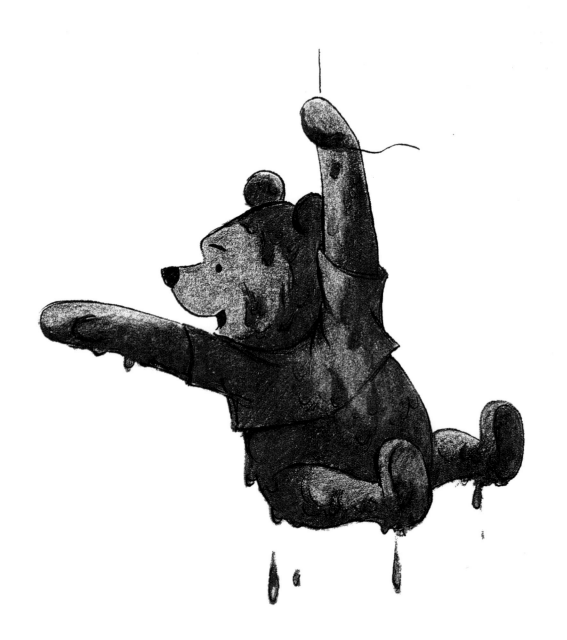

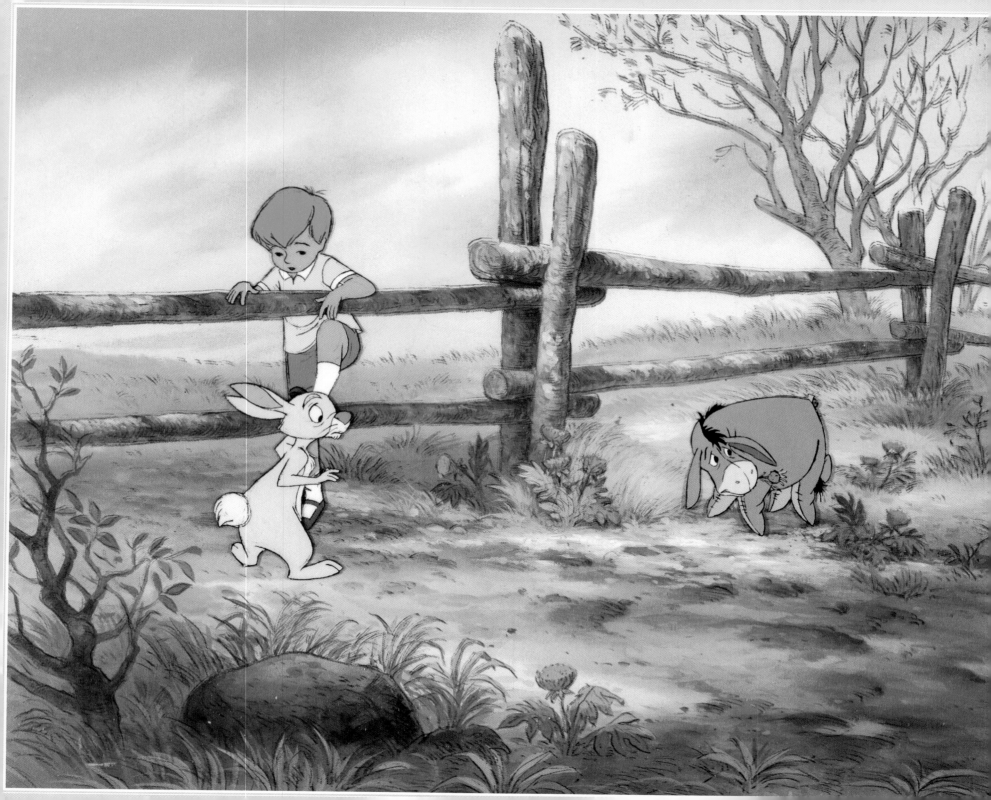

Disney's
Winnie the Pooh

A CELEBRATION OF THE SILLY OLD BEAR

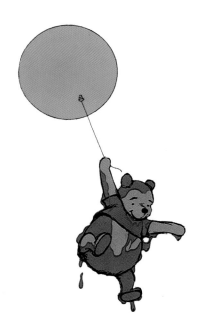

by Christopher Robin Finch

A WELCOME BOOK

EDITIONS

New York

ACKNOWLEDGMENTS

Special thanks are due to Frank Thomas and Ollie Johnston who provided priceless insights into Walt's attitude towards presenting Pooh to the movie-going public. Thanks too to Dave Smith for uncovering important background information, to Ken Shue for supplying me with visual references, to Howard Green for unfailing support, and to Wendy Lefkon for her patience in bringing this project to fulfillment. As always, my wife Linda read the manuscript and offered valuable insights and suggestions. Finally, I would like to express my gratitude to an old friend, the late Lynn Armstrong, with whom I had the pleasure of exploring the real life model for the Hundred-Acre Wood and who was responsible for my long-ago meeting with my namesake, the original Christopher Robin. —*Christopher Finch*

The producers also wish to acknowledge the following people for their indispensable contributions to this book: Larry Ishino, Fox Carney, and Lella Smith at the Animation Research Library; Ed Squair at the Photo Library; John Hanley of Toppan Printing Co. Ltd.; and photographer Michael Stern.

For information address DISNEY EDITIONS
114 Fifth Avenue, New York, New York 10011

Produced by WELCOME ENTERPRISES, INC.
588 Broadway, New York, New York 10012

Project Director: Alice Wong
Designer: Jon Glick
Disney Editions Editorial Director: Wendy Lefkon
Disney Editions Senior Editor: Sara Baysinger
Disney Editions Associate Editor: Rich Thomas

Illustrations on pages 19, 38, 75, 127, 157, 174-75, and 178 by E. H. Shepard, from *The House at Pooh Corner* by A. A. Milne, illustrated by E. H. Shepard, copyright 1928 by E. P. Dutton, renewed © 1956 by A. A. Milne. Used by permission of Dutton Children's Books, a division of Penguin Putnam Inc.

Illustrations on page 2, 17, 32-33, 37, 46-47, 114, 136, and 154 by E. H. Shepard, from *Winnie-the-Pooh* by A. A. Milne, illustrated by E. H. Shepard, copyright 1926 by E. P. Dutton, renewed © 1954 by A. A. Milne. Used by permission of Dutton Children's Books, a division of Penguin Putnam Inc.

Art on page 16 and 24 from Bettmann/Corbis.
Art on page 18 © E. O. Hoppé/Corbis.
Art on page 30-31 from the collection of the Central Children's Room, Donnell Library Center, The New York Public Library.
Art on page 167 © Disney. Based on the "Winnie-the-Pooh" works. © A. A. Milne and E. H. Shepard.

Library of Congress Cataloging-in-Publication Data

Finch, Christopher.
 Disney's Winnie the Pooh: a celebration of the silly old bear/
 by Christopher Robin Finch.
 p. cm.
 "A Welcome book."
 Includes index.
 ISBN 0-7868-6352-8
 1. Milne, A. A. (Alan Alexander), 1882-1956—Characters—Winnie-the-Pooh. 2. Milne, A. A. (Alan Alexander), 1882-1956—Film and video adaptations. 3. Milne, A. A. (Alan Alexander), 1882-1956—Illustrations. 4. Children's stories, English—Film and video adaptations. 5. Children's stories, English—Illustrations. 6. Winnie-the-Pooh (Fictitious character) 7. Teddy bears in literature. 8. Toys in literature. 9. Teddy bears in art. 10. Toys in art. I. Title. II. Title: Winnie the Pooh.
PR6025.I65Z64 2000
791.43'6—DC21 98-23262
 CIP
ISBN: 0-7868-6352-8

First Edition
10 9 8 7 6 5 4 3 2 1

Jacket printed in Japan.
Book printed and bound in China by Toppan Printing Co, Ltd.

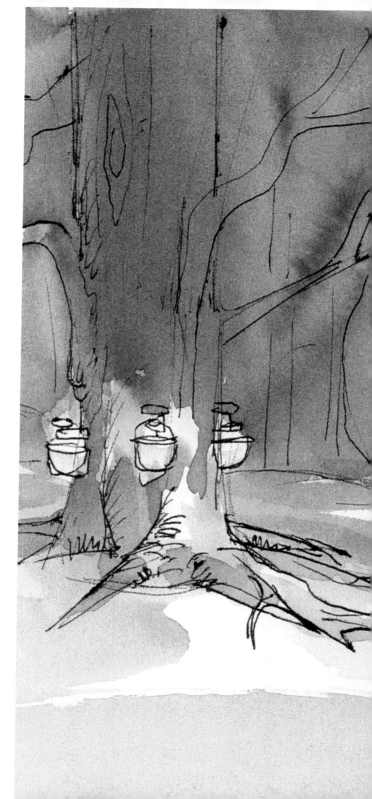

PAGE ONE: *Concept art for* Winnie the Pooh and the Honey Tree.

PAGE TWO: *Cel setup from Scene 79.3 of* Winnie the Pooh and the Blustery Day.

PAGE THREE: *Cel from Scene 306 of* Winnie the Pooh and the Honey Tree.

THESE PAGES: *Concept art for* Winnie the Pooh and the Honey Tree.

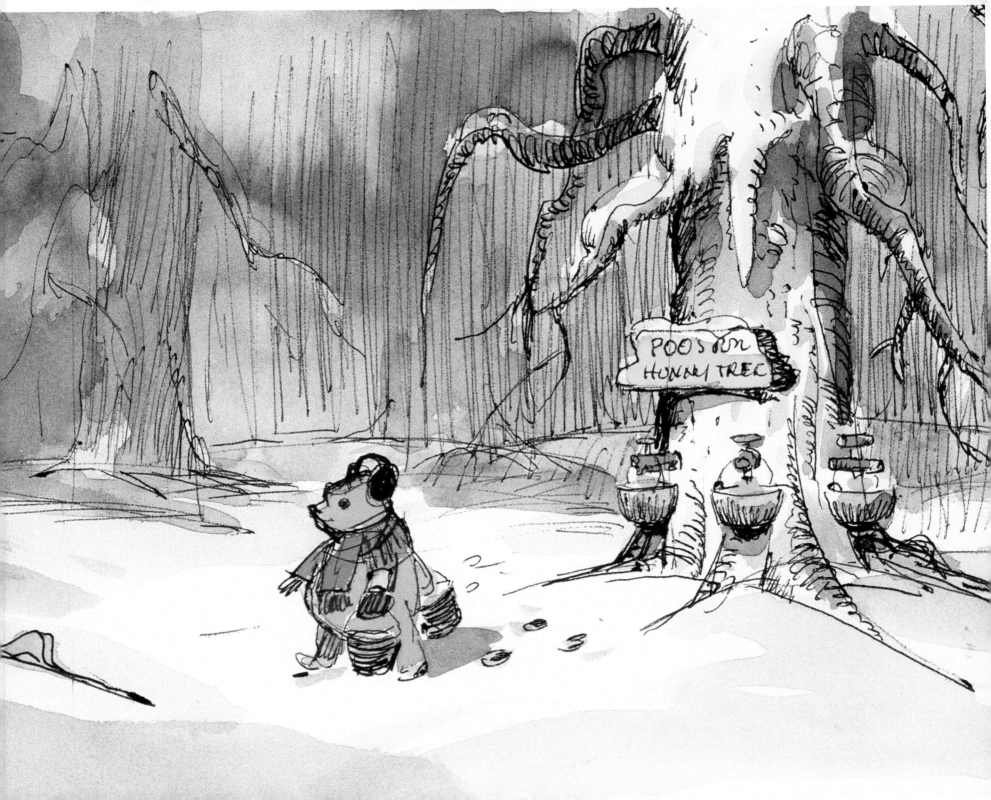

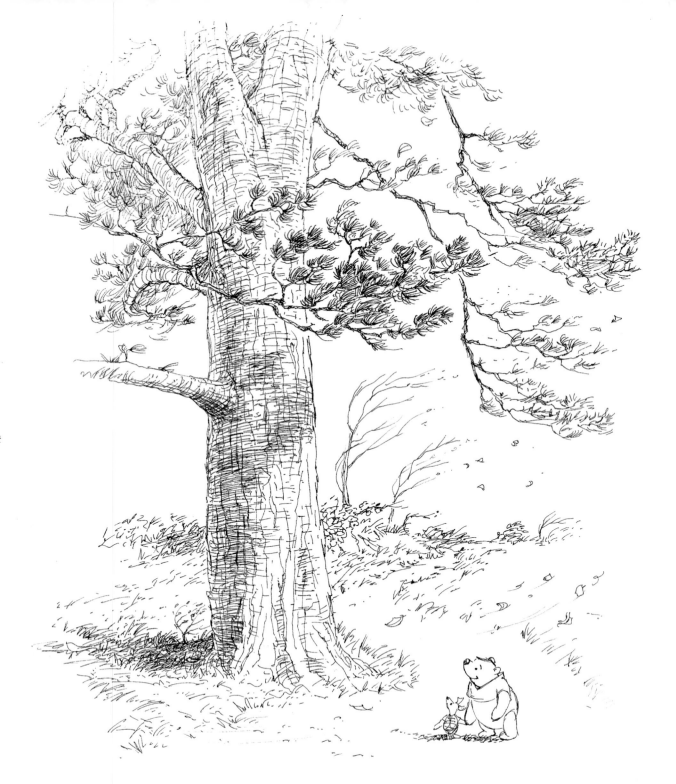

RIGHT: *Concept art
for* Winnie the
Pooh and the
Blustery Day.

CONTENTS

TOP: *Concept art for* Winnie the Pooh and the Honey Tree.

ABOVE: *Cel from Scene 303 of* Winnie the Pooh and Tigger Too.

ABOVE: *Concept art for* Winnie the Pooh and the Honey Tree.

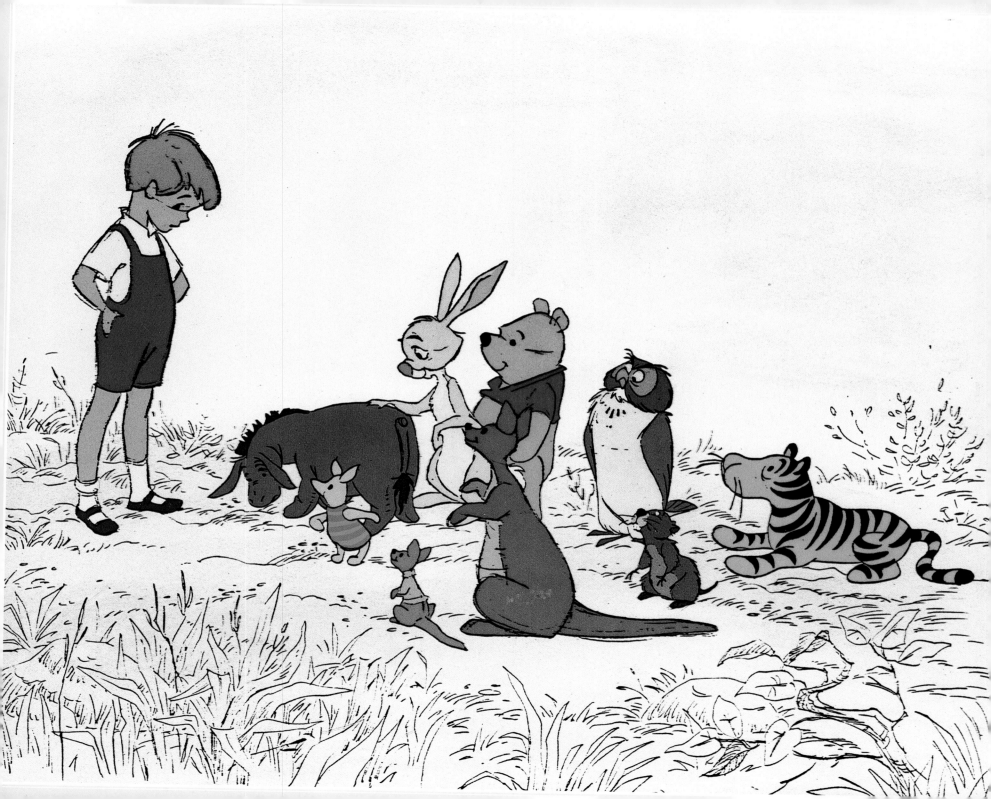

FOREWORD

by Christopher Robin Finch

I HAVE TO CONFESS that my interest in Winnie the Pooh is neither casual nor impartial. The reason for this is that my name happens to be Christopher Robin. I am not *the* Christopher Robin—he was an adult by the time I was born—but I am someone who grew up with that now mythical conjunction of given names and for whom, therefore, the Pooh stories cannot be entirely disentangled from my own sense of identity.

In addition, I lived for a while on a London square just a block from the brick house in which the original Christopher Robin was born and grew up. And, by chance, I also came OPPOSITE: *Concept art for* to be quite familiar with the fringes of the Ashdown Forest where the *Winnie the Pooh and* original Christopher Robin spent weekends and where the Pooh stories *the Honey Tree.* are set. In short, everything has conspired to compromise my objectivity.

It might easily have been otherwise since my parents had no intention of calling me Christopher Robin, but while my mother was pregnant my paternal grandfather sent frequent letters inquiring, "How is little Christopher Robin?" My parents knew a heavy-handed hint when they encountered one and decided to grant him his wish.

I am not sure at what moment I first became aware that Christopher Robin was not just another name. At first, when my father sang about Christopher Robin (he was the tenor in the family), or when my mother read from *When We Were Very Young* at bedtime, I vaguely wondered who had taken the time to write all these verses specially for me.

Hush! Hush! Whisper who dares!
Christopher Robin is saying his prayers.

There was something reassuring about hearing my name in this rhymed context. As I became a little older, though—four or five, perhaps—I began to sense that I was not the only Christopher Robin in the world. I had reached the age when, like Eeyore, I sometimes stood alone in a thistly corner of the forest and entertained thoughts such as "Why?" and "Wherefore?" and even "Inasmuch as which?" So it was that, prompted by the first stirrings of deductive reasoning, I became aware that there was an author called A. A. Milne who wrote the poems and that he had a son who was Christopher Robin before I was, though at the same time I pictured this Christopher Robin as being identical to me in age and other particulars. He became a sort of literary alter ego, existing in a parallel universe. In any case, I did not allow this to turn

into a crisis. There was room for more than one Christopher Robin, I believed. At the very least, it was not a common or garden-type name like Bob or Jim.

Oddly enough, I do not recall encountering Pooh and Piglet and Eeyore and Tigger and the rest of the Pooh Corner gang until after I knew many of the Christopher Robin poems by heart. Certainly I didn't own any officially designated Pooh toys. My Pooh was a panda called Panda. I do not remember family members reading the Pooh books to me. But then, when I was five or six, the British Broadcasting Corporation began to transmit radio adaptations of Winnie the Pooh's adventures on *The Children's Hour*, a daily program.

These adaptations were very faithful to the original, with one actor reading the Milne narrative and others performing the dialogue. It bothered me a little that Christopher Robin seemed to be played by a girl, but the voices were all wonderfully expressive and I found myself enchanted by adventures such as Piglet's meeting with a Heffalump and the "expotition" to the North Pole led by my namesake. In particular, I can remember Pooh's voice, which properly expressed his littleness of mind, and especially the songs he sang:

"How sweet to be a Cloud
 Floating in the Blue!"
It makes him very proud
To be a little cloud.

By this time I could read and so I obtained copies of the Pooh books— perhaps they were already in the house— and relived the adventures in print, to

which was added the dimension provided by Ernest Shepard's wonderful line illustrations (described on the jacket copy as "decorations").

I read both *Winnie-the-Pooh* and *The House at Pooh Corner* many times, and I listened to the BBC adaptations whenever they were rebroadcast. Gradually, though, I progressed to other forms of literary escapism, but without ever entirely losing my sense of Christopher Robin-ness. And sometimes wondering if my personality would have been different if I had been named after some other fictional character.

For a while I formed the impression that Christopher Robin was not a good name for a teenager: not in the era of James Dean and Elvis Presley. I was mistaken, however, soon discovering that many attractive young women rather liked that unthreatening image of the little boy in the short pants and Wellington boots. On being informed of my full name they not infrequently bared their souls and confessed that they still slept with the stuffed likeness of Tigger or Piglet or Pooh himself, which opened up interesting lines of discourse.

For everyday purposes I was "Chris" or "Christopher," but it was no secret that there was a "Robin" lurking somewhere in the middleground. Certainly it was known to my friend Lynn Selden and her family.

Lynn's father was an antique dealer in the Sussex resort town of Eastbourne. One weekend, we went to meet him at a country auction held in a village hall somewhere in the Kent-Sussex border country, not far from the town of Battle. After the auction, Mr. Selden waved me over and introduced me to a

RIGHT: *Concept art for* Winnie the Pooh and the Honey Tree.

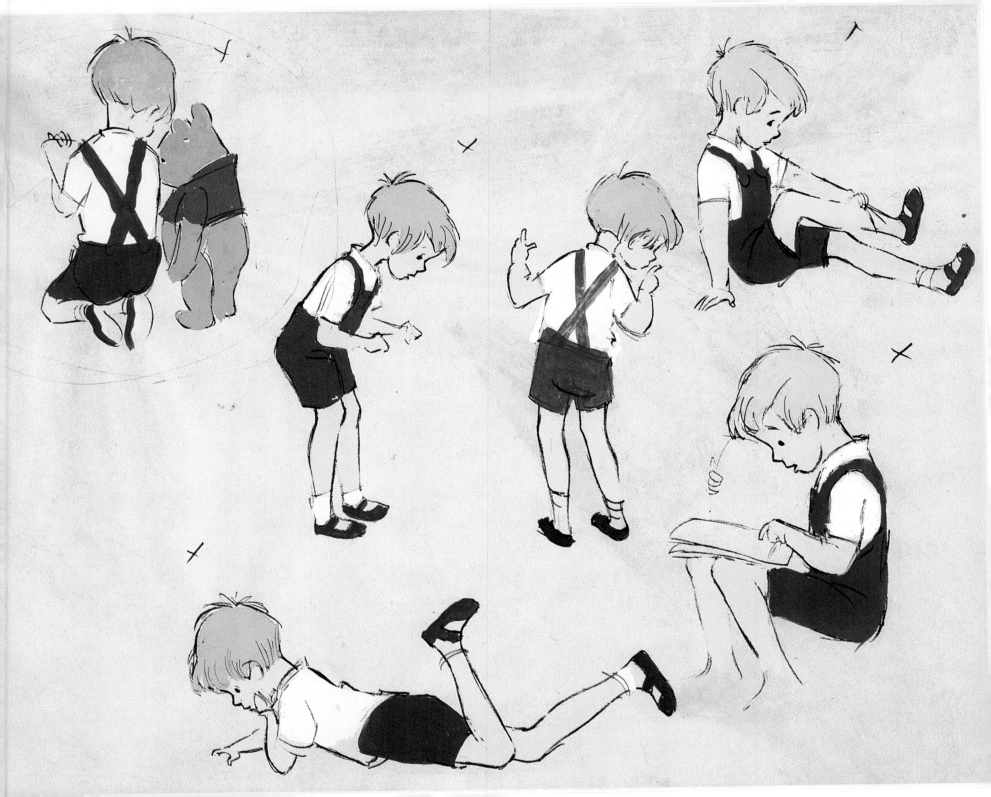

bespectacled man in early middle age, neatly dressed, as I recall, in a sports coat and flannels.

"Christopher," he said, "I'd like you to meet your namesake, Christopher Milne."

It took a moment for the penny to drop.

"Christopher Robin Milne," Mr. Selden prompted.

Then I remembered that I had heard or read that the original Christopher Robin was now an antique dealer. Or was he a bookseller? Something of the sort. I couldn't think of anything original to say and so muttered something like, "Pleased to meet you."

"I understand," said Christopher Milne, "that you're a Christopher Robin too."

I admitted that I was.

He looked at me with sympathy. "I hope," he said, "that the name brings you more satisfaction than it brought me."

This was delivered pleasantly enough, yet I sensed that he had agreed to allow Mr. Selden to introduce us out of politeness rather than with any real pleasure.

Later I learned that Christopher Milne had rarely been called Christopher Robin by his family, who knew him as Billy at first, then Moon, then just plain Christopher, and that he had come to detest the books that had made his name famous, doing everything he could to distance himself from the arcadia his father had spun around him.

Growing up in Paradise, after all, is not necessarily an ideal preparation for the real world. Christopher Milne suggests as much in his memoir, *The Enchanted Places*, even as he describes a

childhood that seems to unfold in a kind of twilit Eden. He acknowledges that there was a time he could identify with the Christopher Robin of the books but talks also of "the years trying to escape from him."

"So if I seem ill at ease posing as Christopher Robin," he wrote, "this is because posing as Christopher Robin does today make me feel ill at ease."

For Christopher Milne, I think, Christopher Robin had become an entirely fictional character, totally unrelated to his own self-image. He had re-invented himself and was not thrilled at being reminded—by meeting me, for instance—of the effort that must have been involved in overcoming the characterization that had been so successfully imposed upon him.

And perhaps his father anticipated that this was bound to happen.

"Pooh," says the fictional Christopher Robin, on the penultimate page of *The House at Pooh Corner*, "*whatever* happens, you *will* understand, won't you?"

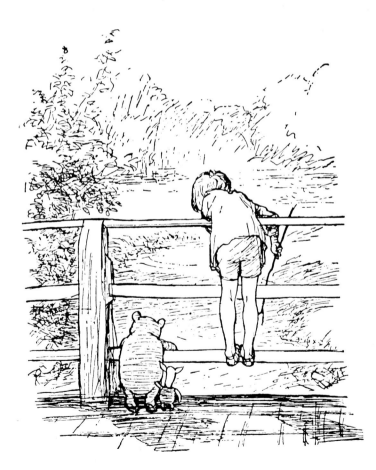

LEFT: *Pooh and Christopher Robin at the Pooh Sticks Bridge. Ernest H. Shepard illustration from page iv of* The House at Pooh Corner.

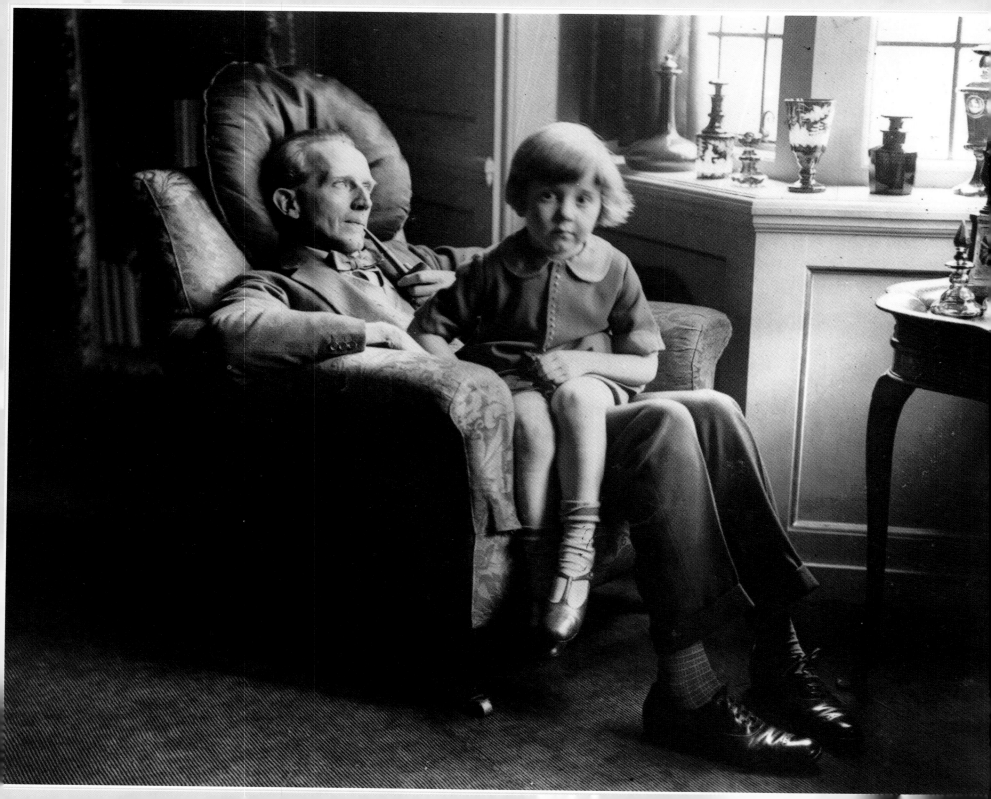

CHAPTER ONE

In Which

The Origins of Winnie the Pooh Are Discussed

ALAN ALEXANDER MILNE was born on January 18, 1882, in London, the third and youngest son of John Milne, the headmaster of a small private school called Henley House, and his wife, Sarah. Alan received his early education at Henley House, where H.G. Wells was for a time the science master, then attended Westminster School in the shadow of the Abbey and the Houses of Parliament. Later he went on to Trinity College, Cambridge, where he and his brother Ken collaborated on light verse that was published in the university's magazine *Granta*.

Alan and Ken would remain close till the latter's death, but their literary partnership ended early and Alan went on alone to become *Granta*'s editor before graduating in 1903 with a degree in mathematics. That same year he made his professional debut, in *Vanity Fair*,

OPPOSITE: *A. A. Milne and Christopher Robin at their home in England, 1925.*

which he followed up with frequent contributions to the humor magazine *Punch*, where he became an assistant editor in 1906. In 1913 he married Dorothy de Selincourt—more usually called Daphne—the goddaughter of *Punch*'s editor, Owen Seaman.

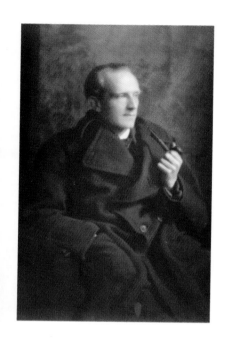

During World War I, Alan Milne served in the army as a signals officer. In 1916, after several months at the front, he was sent home to recuperate from trench fever, and in 1917 his one-act play *Wurzel-Flummery* was performed on a triple bill with two works by his friend and mentor J. M. Barrie, the author of *Peter Pan*.

Discharged from the army on February 14, 1919, Milne found that his position at *Punch* had been filled, and he decided to concentrate on his career as a playwright. This proved to be a sound decision; in 1920 he enjoyed his first major theatrical success with *Mr. Pim Passes By*.

That same year, on August 21, Christopher Robin Milne—Alan and Daphne's only child—was born. Alan is on record as wishing the child had been a girl:

"We had intended," he wrote in his autobiography, "to call it *Rosemary*, but decided that *Billy* would be more suitable. However, as you can't be christened William—at least, we didn't see why anybody should—we had to think of two other names, two initials being necessary to ensure him any sort of copyright in a cognomen as often plagiarized as Milne. One of us thought of Robin and the other of Christopher, names wasted on him who called himself Billy Moon as soon as he could talk, and has been Moon to his family and friends ever since."

"Moon" was the child's way of pronouncing "Milne."

After his son's birth, Alan continued to turn out plays, and novels too, such as *The Red House Mystery*, but his place in history was to depend upon the four classic children's books he

published between 1924 and 1928. These were preceded by the initial Christopher Robin poem, "Vespers," published in *Vanity Fair* in 1923. The poem received much favorable attention and led to the first of his two collections of verse for children, *When We Were Very Young* (1924). This was an immediate hit, and the money it earned helped put the family in the position of being able to purchase a weekend retreat, a Sussex farmhouse located at the edge of the Ashdown Forest, a magical patchwork of woodland and heath a short distance from London by car or train. This became the setting for *Winnie-the-Pooh* (1926), a book of stories featuring Christopher Robin and his toys. The following year Milne published a second book of verse, *Now We Are Six*, and in 1928 he rounded out the cycle with *The House at*

Pooh Corner, which collected the remaining Pooh stories.

All four books were illustrated by *Punch* illustrator Ernest Shepard, and all four were extremely successful, in both England and America initially, and then, after being translated into thirty-three languages (by recent count), around the world.

As for A. A. Milne, he lived almost thirty years after taking leave of Pooh, but never wrote for children again. (His popular stage adaptation of Kenneth Grahame's *The Wind in the Willows*, entitled *Toad of Toad Hall*, was published in 1929 but had been written in 1921.) For many years, in fact, Milne resented that so many people thought of him solely as a children's book author when he was in fact also the author of witty adult comedies and clever mysteries. Toward the end of his life, however, he became

reconciled to the enduring fame of his most famous character, Pooh, and acknowledged that "I can almost regard him as the creation of one of my favorite authors."

Despite his international success, the second half of Milne's life was far from happy, though not without sunny interludes. The death by tuberculosis of his brother Ken in 1929 was a severe blow, and although Alan and Daphne remained married they began to lead independent lives, Daphne spending more and more time out of the country, paying long annual visits to New York. Alan, meanwhile, formed an attachment to Leonora Corbett, a young actress who had appeared in one of his plays.

During the thirties, Alan and his son remained close, practicing cricket together during Sussex weekends and spending happy summer vacations with Ken's widow, Maud, and her family at the Dorset shore. Christopher Milne acknowledges as much in *The Enchanted Places*, remarking on the ability seemingly possessed by all the Milnes of being able to slip back into childhood at will. Whether this was entirely healthy is another matter. It was almost as if Alan, now in his fifties, demanded that his son accept him as a sibling—a fellow adolescent.

By the late thirties, A. A. Milne's career was in decline, though royalties from the children's books, and also from earlier plays still popular in repertory, permitted him to support his family in comfort. World War II saw the Milnes abandon their London home and move full time to Sussex. This seems to have led to something of a reconciliation between Alan and

Daphne. Christopher Milne interrupted his college career to join the Royal Engineers and was stationed abroad for most of the war. It was during this period that he began to free himself from what he appears to have decided was an unhealthy dependency upon his father. After the war, he distanced himself still further and, against his parents' wishes, married his first cousin, Lesley de Selincourt. The couple moved to Dartmouth, in the West Country, where they opened a bookstore. It did not feature the Winnie-the-Pooh books. In fact, Christopher Milne made no secret of his emphatic dislike of anything to do with the denizens of Pooh Corner.

His expeditions back to his old stomping grounds became rare. Certainly he did not visit his parents often, even after his father suffered the severe stroke that led to his death on January 31, 1956. Christopher attended his father's memorial service the following month. It was the last time he ever saw his mother, even though she survived another fifteen years. When he attempted to visit her on her deathbed, she is said to have forbidden it, saying, "I don't want him to see me like this."

Happily, during the course of writing his memoirs Christopher Milne found himself able to dredge up fond memories of his father to set alongside the painful ones, and so a sort of posthumous reconciliation was achieved. His mother presented him with a greater problem. She was artistic, he acknowledged, but her brain, in his estimate, was fluff—though he admitted that she did have a knack for hitting the nail on the head, "no matter whose fingers were in the way."

ALL OF THIS is the stuff of polite upper-crust soap opera, suitable for fans of *Masterpiece Theater*. Ultimately, though, what is far more interesting is the eternal arcadian world created by A. A. Milne when he let himself, for a brief time span, slip into the imagination—perhaps the imagined imagination—of Billy Moon.

The central feature of that imaginary world is Winnie the Pooh.

But who is Winnie the Pooh? How did a bear of little brain come to be the possessor of such a splendid name?

The teddy bear craze dates back to 1902, when Theodore Roosevelt, on one of his hunting expeditions, spared the life of a bear cub, a fact that was celebrated in Clifford K. Berryman's famous cartoon syndicated by the *Washington Post*. There had been stuffed bears before this event, but now they took on Roosevelt's familiar name, "Teddy," and no nursery was considered complete without one. Christopher Milne was given his bear for his first birthday. It came from Harrods and was featured in *When We Were Very Young*:

> A bear, however hard he tries,
> Grows tubby without exercise...

To be specific, this was what teddy bear collectors, a serious lot, refer to as an Alpha Farnell, which is to say a bear made in the Alpha workshop of the J. K. Farnell company, a London soft toy manufacturer that was among the first businesses to manufacture plush bears of the modern type. Upholstered in golden mohair, this was an aristocrat of a bruin.

At first this future star appears to have been addressed as "Teddy" or

"Edward Bear." How he became Pooh is not certain, though he seems to have been preceded by a swan to which Christopher Milne gave that same name. Certainly it was Christopher who dubbed the mohair masterpiece "Pooh."

As for the first part of the name—"Winnie"—that is more easily explained. As a child, Christopher Milne was often taken to the London Zoo, where his favorite house guest was an American black bear called Winnie. Named for the city of Winnipeg, the bear had been the mascot of a Canadian army unit that, during World War I, was stationed in England before being shipped to France. Since the Canadians were too

humane to subject a bear to the barbaric conditions at the front, Winnie was loaned to the London Zoo for the duration. After the war, the loan was extended in perpetuity, and Winnie remained a zoo favorite until her death in 1934.

Evidently Winnie was a *very* tame

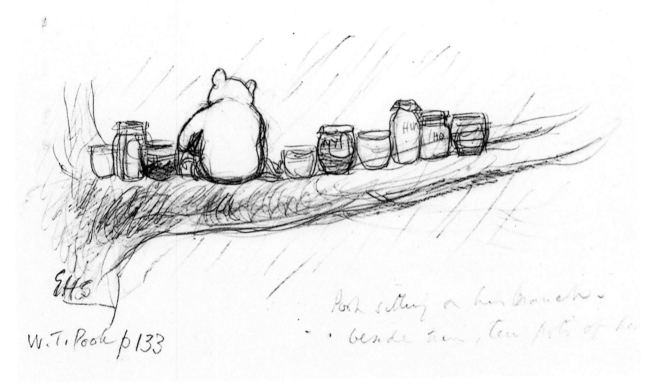

ABOVE: *Pooh sitting on his branch with ten pots of honey. Ernest H. Shepard sketch for Winnie-the-Pooh.*

23

bear, because Christopher Milne was allowed to enter her cage for visits on a regular basis. (There is at least one photograph that substantiates this.) Small wonder, then, that Christopher renamed his stuffed bear Winnie. And if he insisted that Winnie the Pooh was a boy, why should anyone question him?

Winnie-the-Pooh begins with Christopher Robin dragging Pooh downstairs, "bump, bump, bump, on the back of his head," then asking the narrator to "very sweetly" tell Winnie the Pooh a story. In reality the Pooh stories seem to have derived in large part from Alan Milne having observed his son engaged in improvised mini-dramas with his mother, Christopher "puppeteering" his inseparable companion and supplying his gruffly ingenuous voice while Daphne played the other characters embodied by Christopher's remaining

toys, notably Piglet and Eeyore. This is acknowledged by Christopher in his memoirs. His nanny, Olive Rand, reported to an English newspaper many years later that Alan too was adept at engaging Christopher's toys in convincing conversation.

As for the Pooh in Ernest Shepard's illustrations, he derived in part from Christopher Robin's bear, but a second and perhaps more important model was also involved, namely Growler, a teddy bear made by the Steiff company of Germany and owned by Shepard's son, Graham.

As for Pooh's supporting cast, Eeyore was a Christmas present whose neck had lost its stiffening over time so that he took on the morose appearance on which his personality was predicated. Piglet was a gift from a neighbor in Chelsea (where for more than twenty

ABOVE: *Christopher Robin with his teddy bear, Winnie the Pooh.*

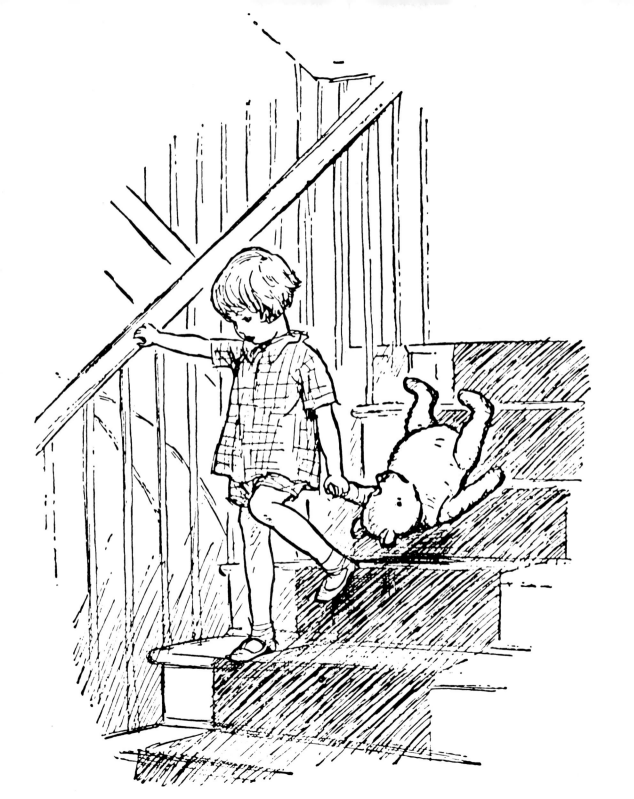

LEFT: *"Bump, bump, bump..." Edward Bear comes down the stairs behind Christopher Robin. Ernest H. Shepard illustration from page 2 of* Winnie-the-Pooh.

25

years the Milnes made their home on Mallord Street, just off the King's Road). Rabbit and Owl were invented to the extent that they were not toys but rather plausible citizens of the fictionalized Ashdown Forest. Later, when more characters were needed to give variety to the stories, Alan and Daphne headed back to Harrods toy department, where they found Kanga and Roo. Later still, Tigger too was added to the menagerie, partly as a plaything for Moon and partly as an addition to the cast.

But if this seems calculating—and Christopher Milne may have come to feel that it was—the stories themselves display no hint of conscious exploitiveness. They display the same sense of unforced innocence that is apparent in other British children's classics such as *Peter Pan*, *Alice in Wonderland* and *Through the Looking-Glass*, and *The Wind in the Willows*.

The Pooh characters actually made their public debut on Christmas Eve, 1925, when the first chapter of *Winnie-the-Pooh* was published by the *London Evening News* under a huge front-page banner headline which announced A CHILDREN'S STORY BY A. A. MILNE. Interestingly, the illustrations were not by Shepard but by a competent artist named J. H. Dowd. At 7:45 PM on Christmas Day the same episode was presented over the airwaves of 2LO, the London station of the BBC, read by a Mr. Donald Calthrop.

Published in its complete form in the autumn of 1926 by Methuen in England and Dutton in America, *Winnie-the-Pooh* gets off to a satisfying start, with Milne's introduction providing a transition from the real world to the world of imagination, which is first

encountered—"a very long time ago, now, about last Friday"—in the form of the story of Pooh's balloon-assisted quest for honey and his encounter with the wrong sort of bees. Then it gets better. From the start of chapter II, "In Which Pooh Goes Visiting and Gets into a Tight Place," we are completely in the arcadian dimension, with no need of transitions to reality other than those provided by landmarks approximately rooted in the geography of the Ashdown Forest. (Appropriately, this geography is inverted in the map that comes with the Pooh books. When Christopher Robin and company set out in search of the North Pole, they head due south according to everyday reckoning.)

For almost 150 pages we are privileged to be observers in a world in which Woozles are hunted, rewards are posted for lost tails, and a simple breakfast consists of marmalade spread over a honeycomb or two. Then, after a final party, it's over and we start again.

Interestingly, many of the first readers of *Winnie-the-Pooh* appear to have been adults who bought the book for themselves. This was remarked on at the time by more than one reviewer, and by representatives of the American publisher, E. P. Dutton. Although the book is so British in its idioms and setting, it was perhaps an even bigger hit in America than in England, 150,000 copies being sold between October 21, 1926, the publication date, and December 31 of that same year. Clearly the adventures of Pooh had an appeal that cut across generational and geographical borders.

(To get a full sense of Milne's popularity as a children's author, it should be noted that by the time *Winnie-the-Pooh*

appeared, signed presentation copies of *When We Were Very Young* were being offered by London booksellers for as much as £53—original price 42 shillings—and in New York for $225.)

Despite the runaway success of *Winnie-the-Pooh* and the Christopher Robin poems, Milne decided that there would be just one more outing for Pooh. He remarked in his autobiography that ideas did not flock to him, as seemed to be the case with some other writers. Rather, he had to go out and find them—a way of saying, I think, that his material depended upon direct observation. At first it seems odd that such an imagination should be capable of dreaming up Pooh's world, which is purely fabulous (in the literal sense of that word). In fact, of course, Alan Milne was able to imagine this world by piggy-backing on the imagination of his son. (Christopher writes, in *The*

Enchanted Places, of his father achieving fame by "climbing upon my infant shoulders.")

In defense of the senior Milne, it should be emphasized that he had no advance warning that these children's books would lead to fame, so it's difficult to accept the idea that he deliberately exploited his son. The point is, though, that he saw Pooh's world through Christopher's eyes, and when he realized that Christopher was out-growing Pooh he sensibly understood that his own direct access to Pooh's world was about to close. So *The House at Pooh Corner* was prefaced with what Milne called a "Contradiction" announcing that this was the end of the road.

The *House at Pooh Corner* brought together ten more adventures, making twenty in all. The standard of this second volume is, if anything, even higher than that of the first. Tigger is a splendid

addition to the cast, and episodes such as "Rabbit's Busy Day," "The Search for Small," "Eeyore Joins a Game," and "Tigger Is Unbounced" show off all the characters to splendid effect.

The public loved this book as much as the first, and the reviews were uniformly favorable, with the famous exception of Dorothy Parker's. Writing as "Constant Reader" in *The New Yorker*, the acerbic Miss Parker reported that, having reached page five, "Tonstant Weader fwowed up."

While enhancing the Parker legend, this review did nothing to hurt the Pooh books. They sold steadily through the thirties and enjoyed a renewed popularity during World War II. (Did the public's affection for Prime Minister Churchill, commonly called "Winnie," owe anything to his resemblance to Pooh?)

Then, after the war, Christopher Robin's toys were sent to America where, insured for $50,000, they toured for years, starting in 1947. In 1969 they were returned to England, by Concorde, to be featured in an exhibition devoted to Ernest Shepard at the Victoria and Albert Museum. After that outing they were sent back to the United States, eventually finding a permanent home in the Central Children's Room of the Donnell branch of the New York Public Library.

In 1960, by which time sales figures for the books were already in the millions, a Latin translation of *Winnie-the-Pooh*—*Winnie ille Pooh*—was a surprise bestseller, remaining on the *New York Times* list for twenty weeks.

The following year, Walt Disney acquired the exclusive film rights to the Pooh stories. Like Alice and Toad and Peter Pan before him, Pooh Bear came to Burbank.

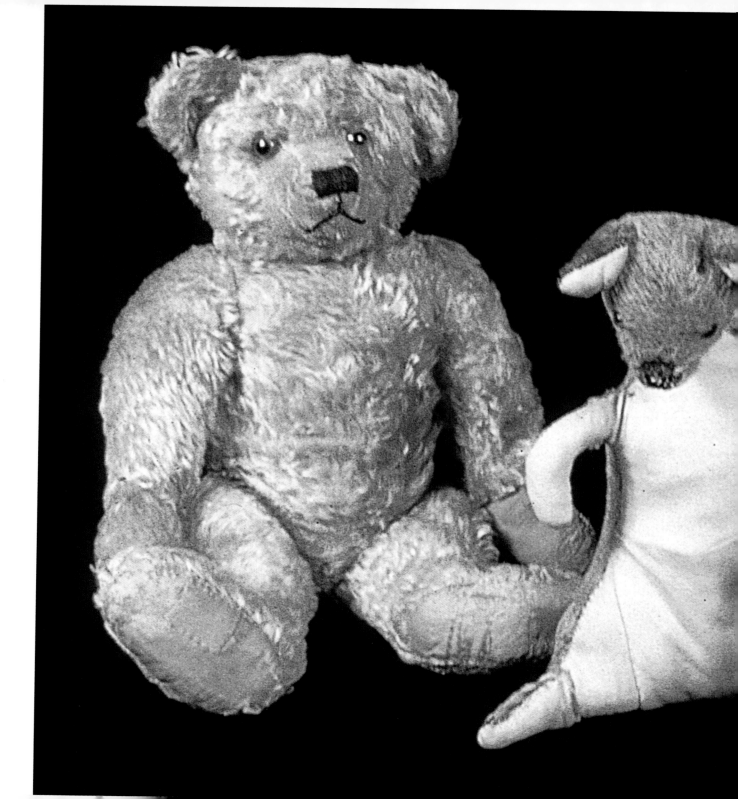

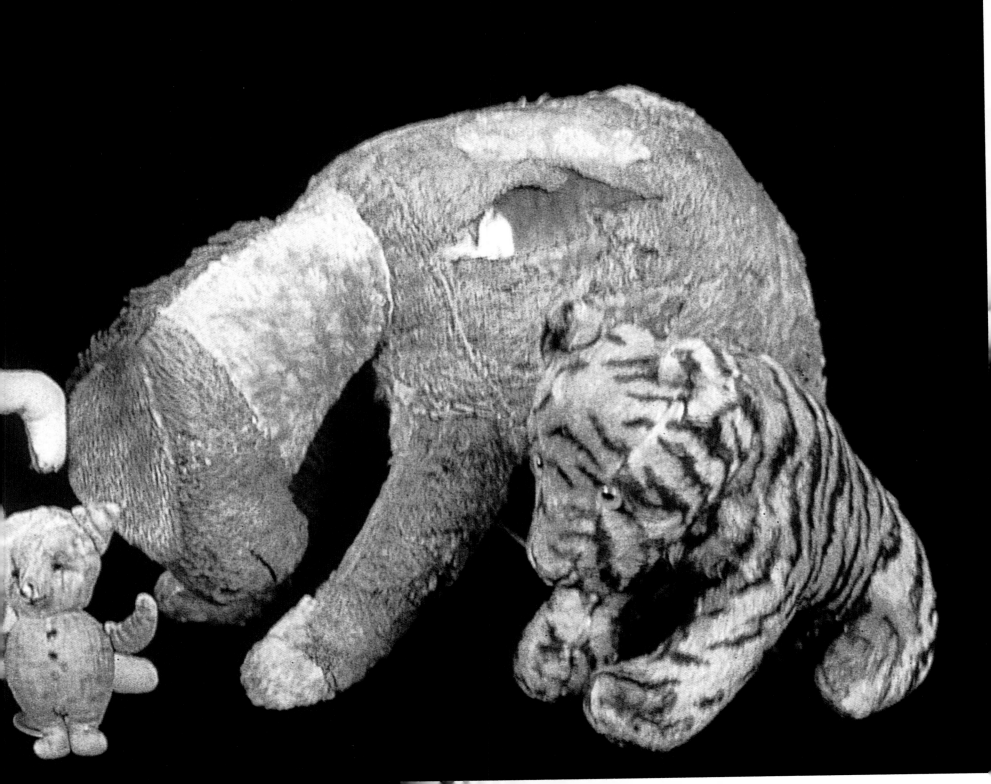

CHAPTER TWO

In Which

Walt Disney Becomes Involved

MANY SELF-APPOINTED KEEPERS OF THE POOH FLAME have assumed that A. A. Milne would have disapproved strongly of Walt Disney appropriating his characters. As one Milne biographer, Ann Thwaite, has pointed out, this is not necessarily true. In 1938 Milne wrote to Kenneth Grahame's widow, Elspeth, "I expect that you've heard that Disney is interested in [*Toad of Toad Hall*]? It's just the thing for him, of course, and he would do it beautifully."

Disney's *Mr. Toad*, released in 1949, is in fact closer in structure to Milne's stage adaptation than to Grahame's *The Wind in the Willows*, upon which both are based. The record shows that Disney began pursuing the rights to *Toad of Toad Hall* soon after his 1937 triumph with *Snow White and the Seven Dwarfs*, and at the same time he instigated correspondence with Curtis Brown, Milne's agent, on the subject of obtaining film rights to the Pooh stories.

OPPOSITE: *Walt Disney and Winnie the Pooh, circa 1965.*

As can be imagined, many of the artists at the Walt Disney Studio were very partial to the Pooh books. They read them to their children and they read them to themselves. "Some of us," recalls animator Ollie Johnston, "could quote whole pages of dialogue by heart." They also greatly admired the illustrations of Ernest Shepard. Walt Disney was aware of this cult but seems never to have given the studio's Pooh enthusiasts any indication that he was seriously interested in obtaining the screen rights to the Milne material. He did not mention it in 1938, nor did he mention it when he renewed his pursuit of those rights on several occasions in the 1940s and 1950s. He seems, in fact, to have deliberately cultivated the impression that he did not have any particular enthusiasm for the inhabitants of the Hundred-Acre Wood.

Theatrical rights to Pooh were never sold during Milne's lifetime. In 1958, however, roughly two years after his death, his wife approved the sale of the motion picture and television rights to the Pooh books to the National Broadcasting Corporation. NBC, it seems, had a Pooh series in mind, but after an unsatisfactory pilot was produced, the project was dropped.

The theatrical rights eventually reverted back to the Milne Estate in 1960. Walt Disney had obviously been keeping an eye on the situation, for he entered into an agreement with the Milne Estate in June of 1961.

Evidently Disney was happy to take over these rights from Milne. Nothing further happened, however, until sometime in 1964, when Disney told

some animation staffers that he was planning a feature based on the Pooh books. (By then he had obtained U.S. marketing rights to the Pooh characters, making a Pooh movie more attractive from a commercial viewpoint because of the possibility of merchandising tie-ins.) A meeting was called with senior staff members to discuss this proposed feature. During the course of that meeting, Disney made a decision. He would *not* make a Pooh feature—not immediately—but would instead produce a Pooh "featurette."

His thinking appears to have been that Americans were not sufficiently familiar with the world of Pooh and Christopher Robin to justify a feature right away. A 25-minute featurette, on the other hand, could be released along with a Disney live-action film, and this,

he reasoned, would create an audience for a future full-length Pooh movie. In view of the fact that the books had been such a success in America, this may seem an oddly conservative approach. The audience for books and the audience for films are not one and the same, however. The fact that *Winnie ille Pooh* could enjoy a long stay on the *New York Times* best-seller list did not automatically translate into movie box-office in the hinterland.

It may be that Disney sensed too that Pooh's low-keyed world, devoid of melodrama and villains, could best be translated to the screen in small increments.

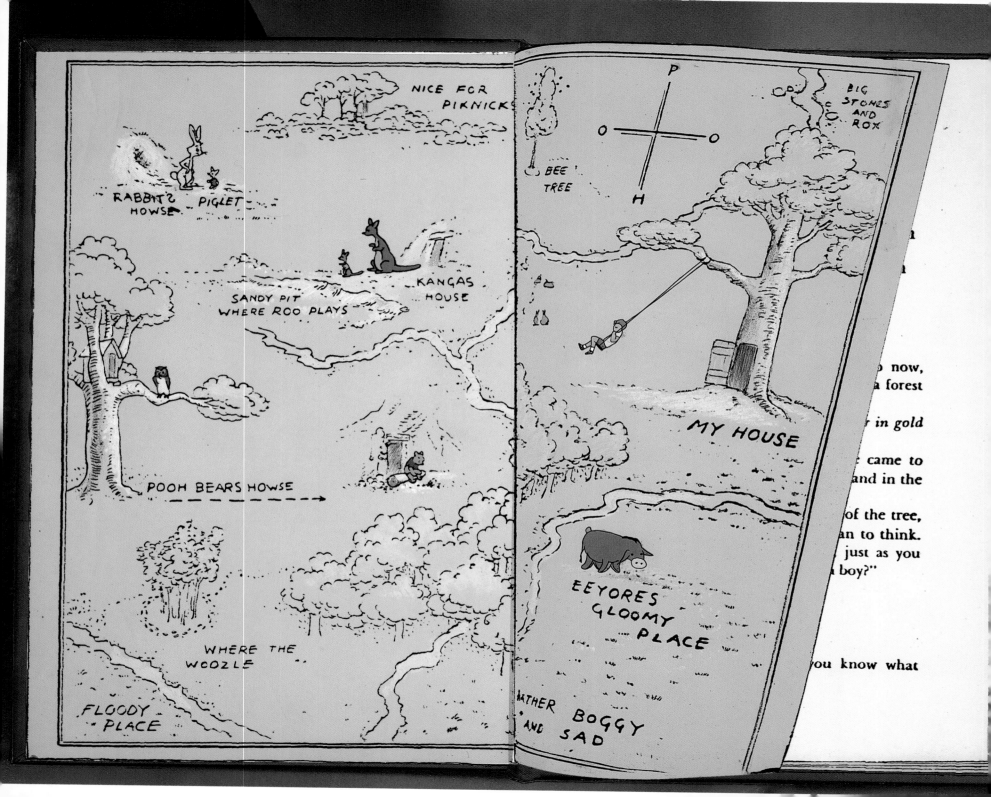

WINNIE THE POOH AND THE HONEY TREE

Winnie the Pooh and the Honey Tree would be based on the first chapters of *Winnie-the-Pooh*, those titled "We Are Introduced" and "Pooh Goes Visiting," with additional snippets of material from elsewhere in the same volume. This made good sense, since the material selected was ideal for familiarizing audiences with several of the principal characters. Instead of assigning avowed Pooh enthusiasts to the project, however, Disney handed the film over to a group of artists who, though certainly talented, had no special interest in the Milne stories—and who in some cases felt positively hostile to them.

"We were pretty surprised," says Frank Thomas. "Walt didn't bother to explain, of course, but so far as we could

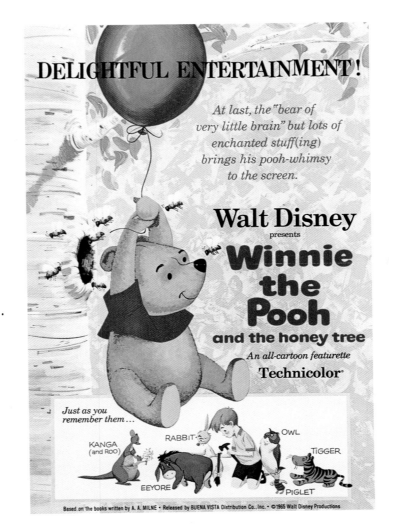

LEFT: *Poster for* Winnie the Pooh and the Honey Tree.

OPPOSITE: *Cel setup from Scene 4.2 of* Winnie the Pooh and the Honey Tree.

figure out, he felt the material was pretty low-keyed to begin with and he was afraid that if Ollie and myself, and Milt Kahl, and some of the other Pooh fans got hold of it we would want to stay too

37

close to the book and that, I suppose he thought, would make for something too precious."

Johnston agrees, adding, "I think Walt was keen to turn the Pooh material into something that would be recognizable as a Disney movie. That's probably why he asked Woolie [Reitherman] to direct."

As an animator, Wolfgang Reitherman was responsible for such memorable Disney characters as Monstro the Whale in *Pinocchio*. He had directed *The Sword in the Stone* and would have directing and/or producing credits on all Disney animated features from that point until 1981's *The Fox and the Hound*. As an animator, Reitherman had specialized in

"action" material, and that was what he felt most comfortable with as a director. Far from being thrilled with *Winnie the Pooh and the Honey Tree* as an assignment, Reitherman seems to have looked on it as something of a punishment. What other explanation was there for Walt handing

him this weird British story in which nothing happened?

Probably the actual explanation for this assignment is that Walt Disney counted on Reitherman having this reaction and expected him to do his utmost to turn *Winnie the Pooh and the Honey Tree* into a "typical" Disney movie. Reitherman would be open to Americanizing the characters and beefing up the gags. If Milne purists balked at this and called it sacrilege—so what?

The story team included experienced hands like Ken Anderson, Larry Clemmons, and Xavier Atencio, and benefited from extensive input by Walt himself. Layout and backgrounds were handled by veterans like Basil Davidovich and Al Dempster, while songs were written by the Sherman brothers, Richard and Robert, with additional music supplied by Buddy Baker.

As for the character animators, however, all but one of the studio's top men found themselves assigned to other projects. Marc Davis, for example, was at work on theme park ideas, and—although dying for a chance to bring the Milne/Shepard characters to life—Frank Thomas, Ollie Johnston, and Milt Kahl had been set to work on *The Jungle Book*, which was in the early stages of production. Of Disney's "Nine Old Men," only Eric Larson and John Lounsbery were assigned to animation duty on *Winnie the Pooh and the Honey Tree*. Both had worked on most of the major features going back to *Snow White and the Seven Dwarfs*. Other less well-known but very able veterans assigned to the featurette were Hal King and John Sibley, both of whom had been at the studio since the early forties, and Eric Cleworth, whose character animation credits went back

more than a decade to *Peter Pan*. This was a solid production unit, then, if not quite the studio's A team.

Given Walt Disney's evident reluctance to present the Pooh stories precisely as Milne wrote them, Reitherman and the others were faced with three major problems. How would it be possible to modify Shepard's drawings for animation while approximating his very distinctive style? How would it be possible to translate A. A. Milne's verbal humor into primarily visual terms? And how should an American producer deal with the stories' pronounced Britishness?

The first question was less of a puzzle for the layout artists and background painters. It was possible for them to remain quite faithful to Shepard's idiom while filling out the detail where appropriate and adding color. The background paintings for all the Pooh films are beautifully conceived and executed and do much to preserve the spirit of the books. The animators had a tougher task. It would have been impossible to exactly

BELOW: *Christopher Robin and Pooh at an enchanted place in the Forest. Ernest H. Shepard illustration from pages 174–175 of* The House at Pooh Corner.

LEFT: *The film's layout artists held to the look and feel of Shepard's drawings. Layout drawing from* Winnie the Pooh and the Honey Tree.

RIGHT: *The hatched line style of Shepard's Hundred-Acre Wood is brought into the world of color. Background painting from* Winnie the Pooh and the Honey Tree.

RIGHT: *Pooh falling from the honey tree. Animation from Scene 44 of* Winnie the Pooh and the Honey Tree *by Eric Cleworth.*

BELOW: *Owl. Cel from Scene 520 of* Winnie the Pooh and the Honey Tree.

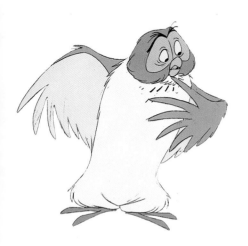

capture Shepard's style—with its fastidious broken lines and delicate hatching—on screen.

"For animation," Frank Thomas explains, "you need a continuous outline. That's almost the opposite of the way Shepard gets his effects."

"And you have to be able to visualize the character from every possible angle," adds Ollie Johnston. "An illustrator can afford to think in two dimensions. An animator has to think in three."

The challenge, then, was to maintain the basic appearance of the individual characters while redesigning them for facility of animation. The result was a greater emphasis on outline and silhouette at the expense of texture.

Anyone who understands the animation medium will appreciate the skill with which this was done. The characters are immediately recognizable to anyone familiar with the books, yet they have been successfully amended to facilitate the animator's task in terms of movement and expressiveness.

Pooh was the most difficult character to animate convincingly, a problem that was exacerbated by the fact that he would be on screen almost continuously and therefore subject to close scrutiny. Some denizens of the Milne stories, like Rabbit and Owl, are based on real animals, and that provides the animator with guidance in terms of convincing movement. As for Eeyore, in the first Pooh film he was not asked to do much and so presented no great difficulty to the animators. But Pooh

himself was tricky because a teddy bear is characterized by stiff movements that are limited by the lack of knee and elbow joints. Given too much flexibility he would no longer seem like a teddy bear. Too much stiffness, on the other hand, would undermine the magic of the story being told.

This was not the first time the Disney artists had faced this kind of problem. When *Pinocchio* went into production, the first animated scenes presented the title character as a puppet without strings, his movements restricted by his primitive artificial joints. The results were so disappointing that Walt Disney immediately closed the picture down until the problem could be solved. The animators started over again, treating

Pinocchio this time as an awkward small boy who slightly exaggerates his movements as if trying each gesture for the first time. This approach was much more successful, allowing the movie to go forward.

There was no such major crisis with Pooh because the problem was better understood by then, but the solution employed was not dissimilar. Pooh was reconceived to permit more naturalistic movement. If the Disney Pooh is compared with the Shepard Pooh, it will be seen that a subtle degree of articulation

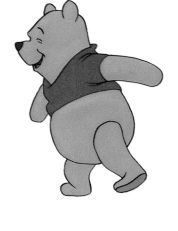

ABOVE & BELOW: *Pooh is allowed more flexibility of movement. Cel and model sheet drawings from* Winnie the Pooh and the Honey Tree.

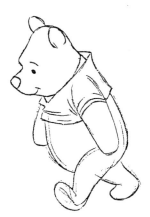
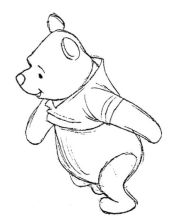

BELOW: *Pooh
hangs on to his balloon
string. Model sheet
drawing from* Winnie
the Pooh and the
Honey Tree.

has been built into the limbs. The legs are a fraction longer in proportion to the body—in some shots, at least—to permit a hint of knee, and there is a suggestion of ankle too in the way the feet are attached. Pooh has also been supplied with thumbs, which turn the conventional teddy bear pads into useful hands (though only, according to model sheets, when this is necessary for gestures or grasping).

Taken as a whole, the movie Pooh still looks like a stuffed animal. It's only when his movements are analyzed and his limbs are observed in action that the modifications can be noticed.

The animation of Pooh in *Winnie the Pooh and the Honey Tree* was not one hundred percent successful. There are a few scenes in which the tendency to stiffness was not overcome. But for the most part the problem of how to bring

him to life was handled efficiently if not brilliantly in this first outing.

One additional way in which the Disney Pooh differed from the Shepard version is that he was given a shrunken red T-shirt to wear. This was based on the Pooh bears made by Agnes Brush and sold at the F.A.O. Schwarz store in New York in the 1940s and 1950s. The pretext for this wardrobe addition seems to have been a single chapter in *Winnie-the-Pooh* in which Pooh wears a T-shirt as protection against the cold. (He and Piglet are hunting in the snow.) From an animation point of view, the T-shirt was probably adopted because it meant there would be less fur texture to deal with. In addition, having a teddy bear in a T-shirt somehow makes the character seem more "personalized" and therefore psychologically easier to animate. The T-shirt functions somewhat like Mickey Mouse's

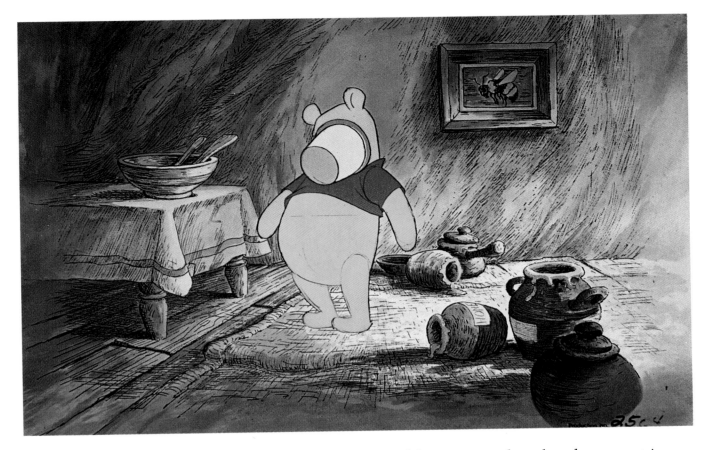

LEFT: *Pooh and his empty honeypots. Cel setup from Scene 24 of* Winnie the Pooh and the Honey Tree.

shorts in the early Disney cartoons. It helps give the character more definition and recognizability than he would have if he was a single all-over color.

Making the characters move convincingly on screen and putting a Disney stamp on them took care of one of the three major problems. Adding extra visual business to that already present in Milne's stories was also crucial. *Winnie the Pooh and the Honey Tree* would be a leisurely paced film by animation standards—no *Tom and Jerry* gag fest—but it could not afford to lose momentum, and its momentum would depend upon uninterrupted visual invention.

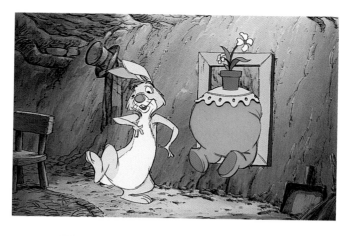

The best example of this in the first Pooh film is the extended sequence in which Rabbit is faced with the fact that he is going to have to live for some time with Pooh's posterior projecting into his living room, Pooh having eaten so much honey that he has become stuck in the entrance to Rabbit's burrow. In the Milne version, Rabbit makes the best of things by hanging his laundry on what is politely referred to as Pooh's "South end." In the film version this is greatly enlarged into a series of efforts by Rabbit to make the best of the situation: attempting to frame Pooh's posterior, placing a potted plant on it,

trying to turn it into a moose head, and finally using it as the back of an armchair. The inspiration for these gags seems to have come from Walt Disney himself.

Walt Disney's determination to remold the stories for the screen was probably influenced by his bitter feelings about the failure—critical as well as financial—of *Alice in Wonderland*. Like *Winnie the Pooh and the Honey Tree*, that 1951 movie was based on a verbally inventive British children's classic that had been enhanced on the page by superb and

THIS PAGE: *Rabbit decorates Pooh's south end. Animation, cel setup, and storyboard art from Scenes 549–558 of* Winnie the Pooh and the Honey Tree.

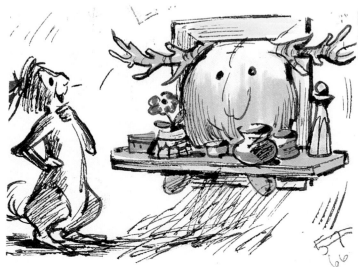

very well-known illustrations (contributed in that instance by John Tenniel). Disney had drawn several conclusions from the failure of this film, not all of them necessarily correct.

One was that it was a mistake to try to translate these British literary classics into animated films. He swore, in fact, that he would never make such an attempt again. When the rights to the Pooh stories became available, he evidently changed his mind—but it seems he may have done so with a conscious or subconscious proviso. In bringing Pooh to the screen, he would make sure his own midwestern stamp was imposed on the stories. One way of doing this was to have Woolie Reitherman, not a Milne and Shepard purist, direct. Reitherman would have no qualms about making changes to suit an American audience.

In *Winnie the Pooh and the Honey Tree* Christopher Robin is given an American accent—his voice provided by Reitherman's son Bruce. Also, Gopher is introduced to the cast. Gophers are not native to the British Isles. This is true of tigers and kangaroos too, of course, but Tigger, Kanga, and Roo are never presented in the books as native animals. Like Pooh himself, they are exotics who have found themselves in the region of the Hundred-Acre Wood by way of Christopher Robin's toy collection. Gopher, by contrast, is presented on screen as an entrenched local resident, like Rabbit and Owl, implying that the movie is set in America.

ABOVE: *Gopher answers the call for an excavation expert. Cel over background overlay from Scene 507.1 of* Winnie the Pooh and the Honey Tree.

LEFT: *Gopher. Cel from* Winnie the Pooh and the Honey Tree.

ABOVE & RIGHT:

*Cels and cel setup from
Scene 2 of* Winnie
the Pooh and the
Honey Tree.

The movie opens with Christopher Robin's bedroom—a very American bedroom furnished in a style that would have seemed quite alien to the vast majority of British children in 1966. Even some of the toys scattered on the floor—the railroad locomotive, for example—are obviously American. The film then cuts to the famous endpaper map of Pooh territory—supposedly drawn by Christopher Robin "and Mr. Shepard"—and simple, understated animation activates every part of the map, introducing the conceit that the book itself is coming alive, and reminding the audience of the film's literary origins. This is a splendid notion that helps sustain the storybook

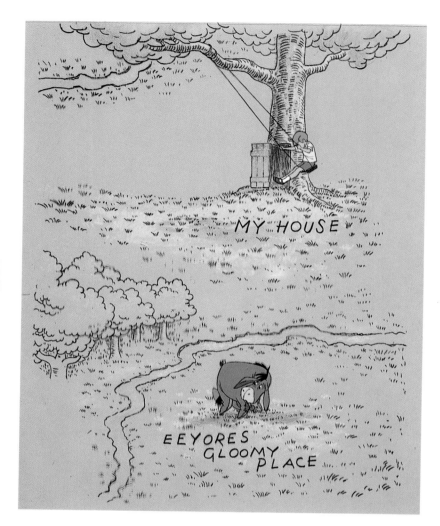

feel of the more conventional film passages and will serve the animators well through this featurette and into future Pooh films.

By embracing this device and nourishing it, Woolie Reitherman was

redeemed because it meant that—whatever the pressures—the movie could not stray hopelessly far from the Pooh books.

Anyone who has read *Winnie-the-Pooh* will see that the film's story does not wander too far from events described in the text, though they have been rearranged to some extent. Whether the movie sticks to the spirit of the text is another matter, and the truth is that there are opposing forces at work in this film that threaten to pull it apart. On the one hand the overly cute voices of some of the characters, the saccharine Sherman and Sherman songs, and a tendency to telegraph the gags work against the spirit of Shepard and Milne. On the plus side can be counted the use of the animated storybook device, some good if not great animation, and the fact that nobody found a way to completely ignore the Milne original. In the voice talent area, the best decision was probably the choice of Sebastian Cabot, whose affectionate feeling for the material is obvious, as narrator. A good word should be put in, too, for Buddy Baker's score, which features a *Peter and the Wolf*–type device in which different instruments are used to introduce the various characters. (Pooh, for example, is represented by the baritone horn, Eeyore by the bass clarinet.)

In America, *Winnie the Pooh and the Honey Tree* was released in February of 1966, along with the eminently forgettable

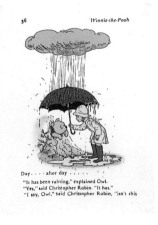

Day after day
"It has been raining," explained Owl.
"Yes," said Christopher Robin. "It has."
"I say, Owl," said Christopher Robin, "isn't this

ABOVE: *Pooh waits to get thin again in a bookpage scene. Cel setup from Scene 562.1 of* Winnie the Pooh and the Honey Tree.

LEFT: *Creating the music for* Winnie the Pooh and the Honey Tree.

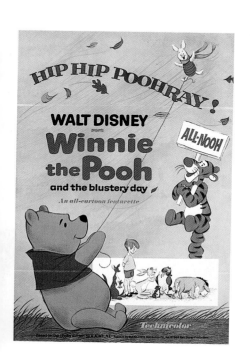

live-action feature *The Ugly Dachshund*, starring Dean Jones and Suzanne Pleshette. Reviews were mixed, but American audiences—adults as well as children—liked Disney's version of Pooh. For a featurette, the movie received a great deal of attention, and it was clear almost from the outset that it was only a matter of time before there would be a sequel.

In Britain it was a very different story. There audiences had mixed reactions to the movie, to say the least, and critics, especially Felix Barker, jumped on it with vehemence and disgust. It became, in fact, a cause célèbre, with one newspaper accusing Walt Disney, in banner headlines, of "murdering" Winnie the Pooh.

Ernest Shepard, still alive in his nineties, pronounced the film a travesty. Daphne Milne is said to have rather liked it.

WINNIE THE POOH AND THE BLUSTERY DAY

Only a short time elapsed before the next Pooh featurette, *Winnie the Pooh and the Blustery Day*, went into production, but by then the situation at the studio had completely changed. On December 15, 1966, just ten months after the release of *Winnie the Pooh and the Honey Tree*, Walt Disney died. At that time the animation staff was close to finishing *The Jungle Book* and was tooling up for *The Aristocats*, to which Disney had given his go-ahead on the strength of a board of drawings by Ken Anderson. In the late summer of 1967, before *The Aristocats* went into full production, it was decided to go ahead with a featurette-length sequel to *Winnie the Pooh and the Honey Tree*.

This made good sense in a couple of ways. Pooh's Disney debut film had

proved to be very popular—in America, anyway—so a follow-up was certainly justified. It must also have seemed like a good idea to choose this modestly scaled film as the animators' first outing without Walt.

In these changed circumstances it seemed to make good sense to put the studio's top available talent to work on the new project. Thus avowed Pooh fans like Frank Thomas, Ollie Johnston, and Milt Kahl were finally called upon, and they seized the opportunity. Woolie Reitherman remained in charge as director, but by now his attitude towards Pooh had changed considerably. After all, *Winnie the Pooh and the Honey Tree* had enhanced his reputation, giving him every reason to feel more sympathetic to the Milne characters. He seems to have understood that the parts that worked best in the first movie were the parts

that were closest to the Milne original, so now he encouraged the animators to mine the books for inspiration.

"Woolie was sometimes reluctant to accept fresh ideas," says Ollie Johnston. "You'd have to work hard to persuade him to try something new, but once you'd demonstrated that your idea made sense then he'd back you up one hundred percent."

"Essentially," says Frank Thomas, "our approach to Pooh was no different from our approach to any other film. The characters were different, however, and the whole secret is to understand the characters. Once you get inside them, then the animation follows. In this instance, of course, Milne had given us wonderful characters to work with."

"This was not a case of an individual animator being assigned to a single character," says Johnston. "The exception

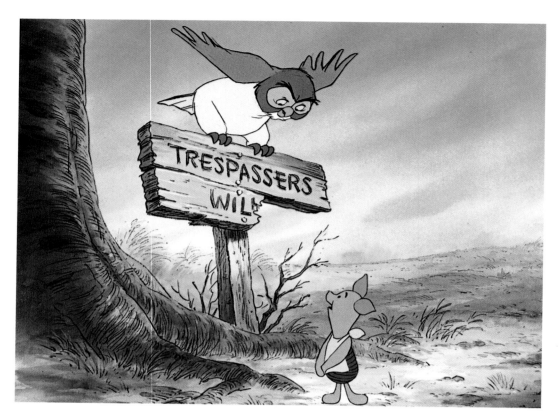

was that Milt Kahl ended up doing almost all of Tigger, but basically this picture was broken down by sequence, so that Frank and I, and John Lounsbery too, each got to do a fair amount of work on scenes involving Pooh and Piglet."

Inexplicably, Piglet had been left out of *Winnie the Pooh and the Honey Tree*—apparently displaced by Gopher—but for the sequel he was restored to the cast and given an appropriately important role. Another change was that Christopher Robin was given a different and more neutral voice, provided by British-born Jon Walmsley, who would soon achieve television fame as Jason on *The Waltons*. In short, the entire approach this time around was geared to the recognition that the Milne stories could be successfully translated to the screen without needing to be jazzed up or excessively Americanized. For the Milne enthusiasts involved with the production, *Winnie the Pooh and the Blustery Day* would become a labor of love.

What we see on screen is evidence enough for this. From the moment Pooh makes his first appearance,

fighting a stiff breeze on his way to his Thoughtful Spot, it's apparent that this at last is the authentic Pooh. Not that he looks significantly different. He's still the same squat teddy bear, three heads high, with the somewhat pear-shaped torso that is partly hidden by the same shrunken red T-shirt that tends to ride up around his nonexistent neck. He has the same button eyes that disappear into crinkles when he laughs, the same upturned muzzle, the same slightly pigeon-toed walk. But in *Winnie the Pooh and the Blustery Day* he moves with a new assurance, his gestures and expressions are more articulate. When he reaches his Thoughtful Spot and sits down to think, we can

LEFT & BELOW: *Pooh skips off happily into the wind on a blustery day. Cel and cel setup from Scenes 1.3 and 2 of* Winnie the Pooh and the Blustery Day.

about, because whichever direction they started in, they always ended up at it, and each time, as it came through the mist at them, Rabbit said triumphantly, "Now I know where we are!" and Pooh said sadly,

turn out to be . . . feels that it will undoubtedly . . . looks like a rather blustery day today, it seems that it may turn out to be . . . looks like a rather blustery day today. "Oh, help!" said Pooh. "I'd better go back." "Oh, bother!" said Pooh. "I shall have to go on." Well, it just happened that you had been to a

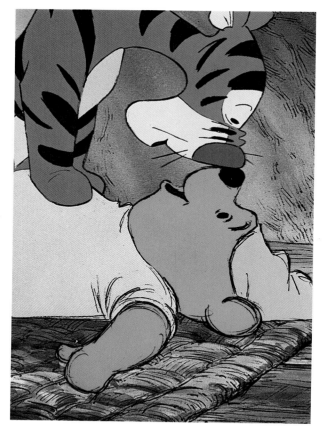

RIGHT: *Tigger and Pooh come nose to nose for the first time. Cel setup from Scene 11.1 of* Winnie the Pooh and the Blustery Day.

BELOW: *Little Piglet is no match for the wind. Animation from Scene 25 of* Winnie the Pooh and the Blustery Day *by Ollie Johnston.*

the Blustery Day. Whether he is skipping through the Hundred-Acre Wood, balancing on a wall, chasing after windblown Piglet, or confronting Tigger for the first time, Pooh always seems completely alive, his movements and expression exactly right. This is a star turn set off by other star turns, notably those provided by Piglet and Tigger.

Piglet is delightful from the moment we meet him proudly sweeping the entranceway to his house. The next sequence, where he fights the increasingly strong winds before finally being

almost see his mind at work, so clearly is his futile attempt at cerebration reflected in the way his brow is scrunched up and his lips are pursed in determination.

In fact, the animation of Pooh is superb all the way through *Winnie the Pooh and*

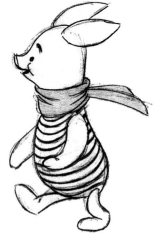

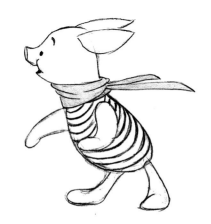

54

blown away, is brilliantly animated by Ollie Johnston.

Tigger makes his memorable appearance soon after Piglet's. When he launches into perhaps the best of the Sherman brothers' Pooh songs, "The Wonderful Thing about Tiggers," the animation is superb. This is an example of Milt Kahl at his best, which is to say an example of the finest the medium has to offer. Kahl endowed Tigger with a manic energy that was well matched by the voice provided by Paul Winchell—an outlandish, vaudeville baritone that is part Ed Wynn, part Hugh Herbert, and part Jimmy Durante.

Winnie the Pooh and the Blustery Day is a small masterpiece of character animation, as good in its way as anything the Disney studio has ever done. It may not have broken new ground like *Snow White and the Seven Dwarfs*, and it may not have been as ambitious as *Fantasia*, but it turned out to be an almost flawless example of character animation, a celebration of the skill that gave the studio its unique place in motion picture history. In fact, there is very little to the film except character animation: some amusing situations, certainly, but none of the melodrama we

ABOVE: *"T-I-double-Guh-er! That spells 'Tigger'!" Cel from* Winnie the Pooh and the Blustery Day.

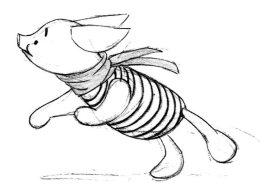

associate with most of the Disney animated classics. This was a movie about Pooh relating to Piglet and Tigger and Christopher Robin and not much else.

The story of *Winnie the Pooh and the Blustery Day* was stitched together from parts of several episodes lifted from the two Pooh books, most notably chapter IX of *Winnie-the-Pooh* ("In Which Piglet Is Entirely Surrounded by Water") and chapters II and VIII of *The House at Pooh*

Corner ("Tigger Has Breakfast" and "Piglet Does a Very Grand Thing"). In some ways *more* liberties were taken with the text than in *Winnie the Pooh and the Honey Tree*, but the changes were made within a context of respect for Milne's achievement that made them completely acceptable.

Released in December of 1968, *Winnie the Pooh and the Blustery Day* was only 25 minutes long, but it is better remembered than all but a handful of the features released by Hollywood studios that year. At the time, reviewers sensed that this movie was superior to its predecessor, and so did audiences, even in Britain. Most tellingly, it gained the immediate respect of its peers, who made it an Academy Award winner for Animated Short Subjects.

BELOW: *(left to right) John Lounsbery, Ollie Johnston, Milt Kahl, Larry Clemmons, Wolfgang Reitherman, Hal King, and Frank Thomas with their Oscar.*

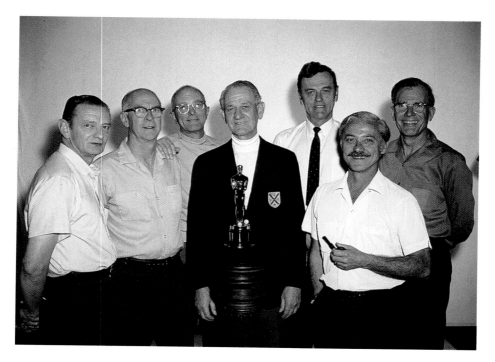

WINNIE THE POOH AND TIGGER TOO

The even greater success of this second Pooh film was more than enough to justify the production of a third. Other projects kept the studio's animators busy, however, and it was 1974 before another sequel appeared. Entitled *Winnie the Pooh and Tigger Too*, this film came close to being as memorable as its predecessor, which is saying a good deal.

Produced between *Robin Hood* and *The Rescuers*, *Winnie the Pooh and Tigger Too* was made at a time when key veteran animators like Milt Kahl, Ollie Johnston, Frank Thomas, and John Lounsbery were still on hand at the studio, where they had been joined by younger artists like Don Bluth (who soon left to produce his own movies) and Andy Gaskill (who would later distinguish himself as art

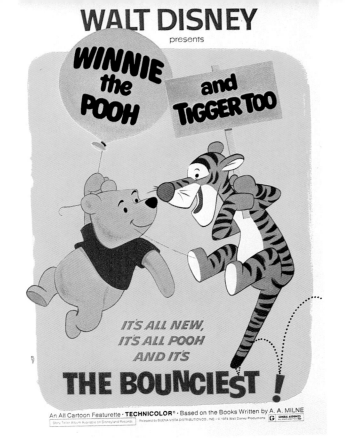

LEFT: *Poster for* Winnie the Pooh and the Tigger Too.

director of *The Lion King*). The talent pool available was considerable, and this is reflected in the quality of the production.

This time the directorial responsibilities were awarded to Lounsbery. Another important change was the voice of Christopher Robin, which finally became convincingly British in the person of Timothy Turner.

As the title suggests, *Winnie the Pooh and Tigger Too* builds upon the great success scored by Milt Kahl's hyperactive version of Tigger in the preceding film. This time the story was pieced together primarily from "Tiggers Don't Climb Trees" and "Tigger Is Unbounced"—chapters IV and VII of *The House at Pooh Corner*—with additional material from other sections, including a key sequence taken from "Pooh and Piglet Go Hunting," chapter III of *Winnie-the-Pooh*.

Like *Winnie the Pooh and the Blustery Day*, *Winnie the Pooh and Tigger Too* is full of inspired animation. Tigger is effectively presented in almost every scene, and especially when out of character—as at the conclusion of the movie when he is clinging for dear life to the trunk of the tree. There is also some clever business with Piglet. Much of this is so subtle it's easy to overlook. Anyone interested in the art of animation, however, would do well to study the simple scene in which Piglet climbs out of the sand pit. His body language and changes in facial expression provide a master class in how to make something out of almost nothing.

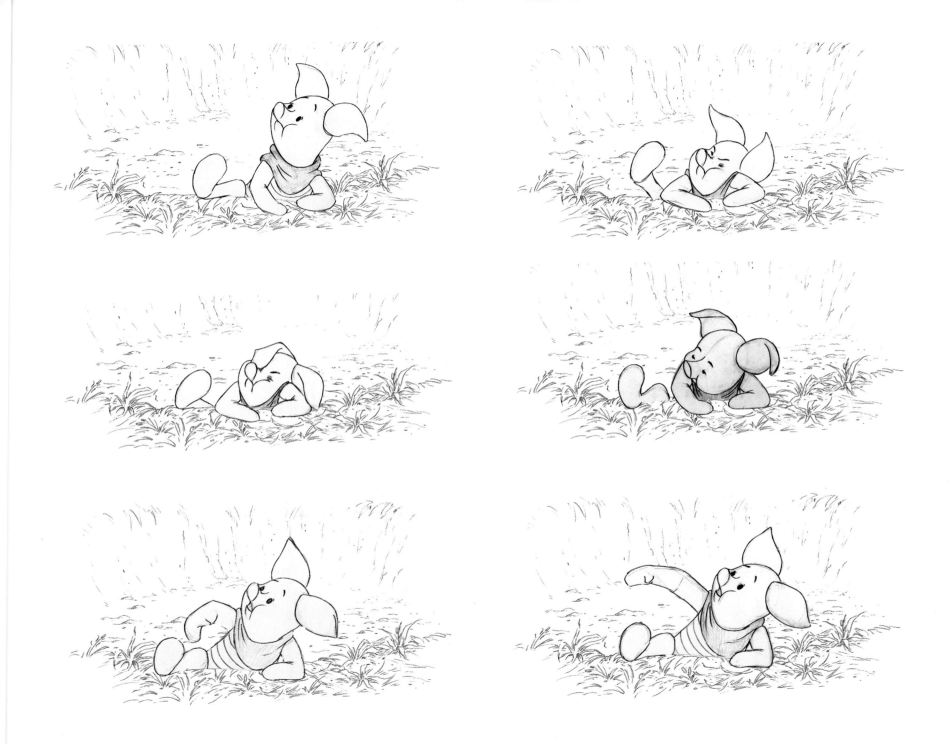

59

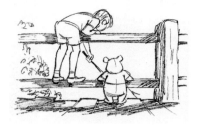

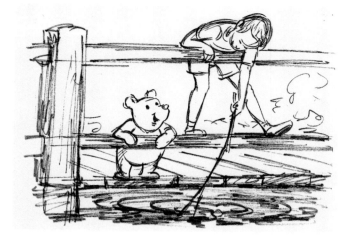

THE MANY ADVENTURES OF WINNIE THE POOH

Walt Disney's original plan for Pooh was finally realized in 1977, when the three featurettes were spliced together—along with some new material and redubbing to make Christopher Robin British throughout—to create the feature-length film *The Many Adventures of Winnie the Pooh*. The additional material consisted mostly of a postscript based on chapter X of *The House at Pooh Corner*, in which Christopher Robin, about to begin school, takes leave of his animal friends, especially Pooh, whom he takes to the Enchanted Place. There they talk about the joys of doing nothing and promise to remember one another always, even when Christopher Robin is a hundred years old and Pooh ninety-nine.

It is the proper Milne ending, handled with appropriate respect by the Disney artists. But this was not the end of Pooh or Christopher Robin as Disney characters. The public wouldn't allow it.

WINNIE THE POOH AND A DAY FOR EEYORE

The success of the original three films prompted the production of a fourth featurette, *Winnie the Pooh and a Day for Eeyore*, which was released theatrically in 1983 and on video the following year. Unlike its predecessors, this movie was

not handled by the elite feature animation unit but was subcontracted to a team of outside animators under the direction of Rick Reinert. By then, of course, the characters were well established, and in fact the animation in this sequel is quite acceptable. As a whole, the film does not match the standard set by *Winnie the Pooh and the Blustery Day* and *Winnie the Pooh and Tigger Too*, but it is nonetheless an entertaining addition to the series.

This time the principal sources were two chapters, one from each of the Pooh books, specifically "Eeyore Has a Birthday," from *Winnie-the-Pooh*, and "Pooh Invents a Game and Eeyore Joins In," from *The House at Pooh Corner.*

One of the best things about this featurette is that it finally focuses some deserved attention on Eeyore. On the negative side, not all the original voice talents were available. Notable absences were Sebastian Cabot as the narrator (he had died in 1977) and Sterling Holloway as Pooh (though Hal Smith did an adequate job of replacing him).

This was to be the last Disney animation based directly on the text of the Milne books.

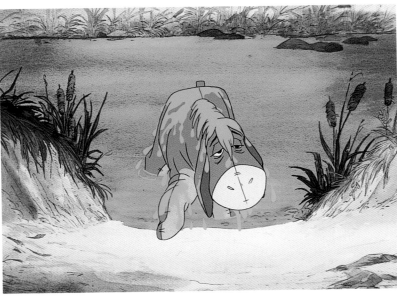

LEFT: *A wet and gloomy Eeyore emerges from the river. Cel setup from* Winnie the Pooh and a Day for Eeyore.

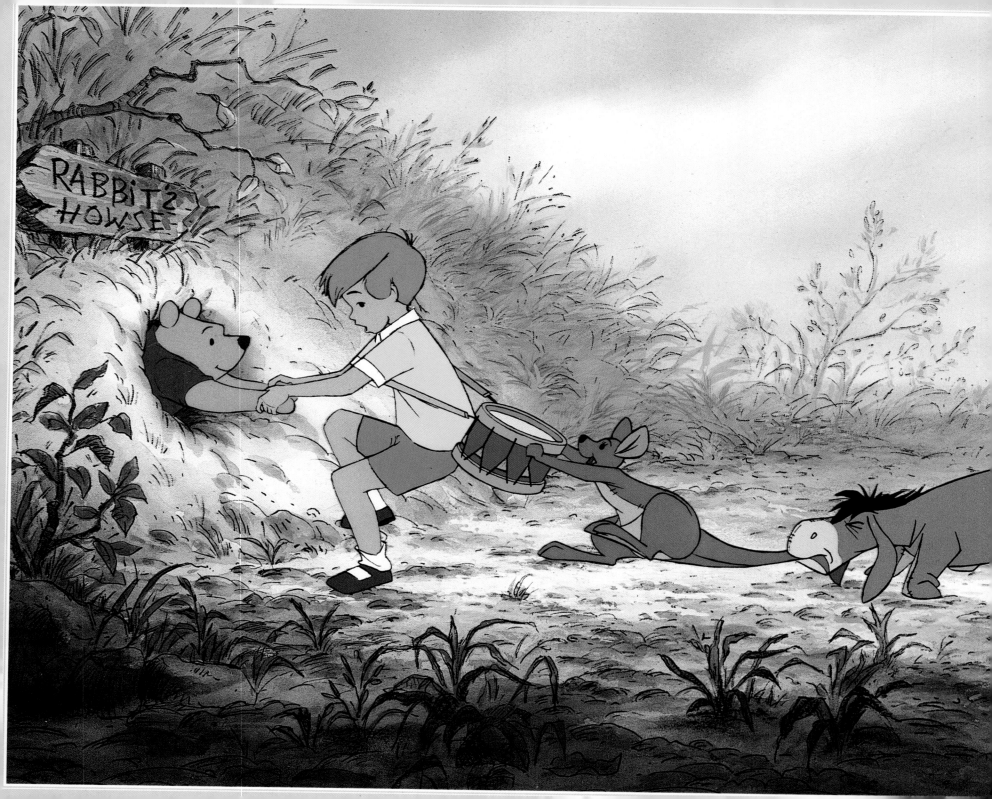

CHAPTER THREE

In Which

The Characters Are Presented

Deep in the Hundred–Acre Wood,

where Christopher Robin plays,

you'll find the enchanted neighborhood of

Christopher's childhood days.

A Donkey named Eeyore is his friend . . .

and Kanga and little Roo.

There's Rabbit and Piglet . . . and there's Owl,

but most of all Winnie the Pooh . . .

OPPOSITE: *Pooh's friends form a tug-of-war to open Rabbit's door. Cel setup from Scene 628 of* Winnie the Pooh and the Honey Tree.

BELOW: *Character development cels from* Winnie the Pooh and the Honey Tree.

CHRISTOPHER ROBIN

ABOVE & FAR RIGHT: *Concept art for* Winnie the Pooh and the Honey Tree.

ABOVE CENTER: *Ernest H. Shepard illustration from page 178 of* The House at Pooh Corner.

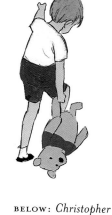

BELOW: *Christopher Robin "spots" a falling Pooh. Rough animation from Scene 335.1 of* Winnie the Pooh and the Honey Tree *by Eric Cleworth.*

OPPOSITE: *Christopher Robin comes to the aid of Owl. Cel setup from Scene 85 of* Winnie the Pooh and the Blustery Day.

Ernest Shepard's book illustrations of Christopher Robin were based on the real-life four-year-old Christopher Milne, as is apparent from Milne family photographs. He is a typical upper-class English boy of the period, given to wearing loose shirts, short shorts, and either sandals or, when the weather is wet, Wellington boots. Also in the style of the period, he wears his hair in a longish, shaggy bob.

When Walt Disney assigned Wolfgang Reitherman to direct the first Pooh movie, Reitherman was bothered by this long hair. To his eye, Shepard's Christopher Robin didn't look like a healthy outdoor kind of kid. A haircut, he decided, was called for. He had not reckoned with the Beatles, however. This was the period when the moptops were making their mark in America. Longer hair was back in vogue, and someone—presumably Walt Disney himself—overruled Reitherman. Christopher Robin kept his hair. He was, though, given a more "boyish" wardrobe and an American accent. His voice did not become convincingly British until the third featurette.

THE CHARACTERS ARE PRESENTED

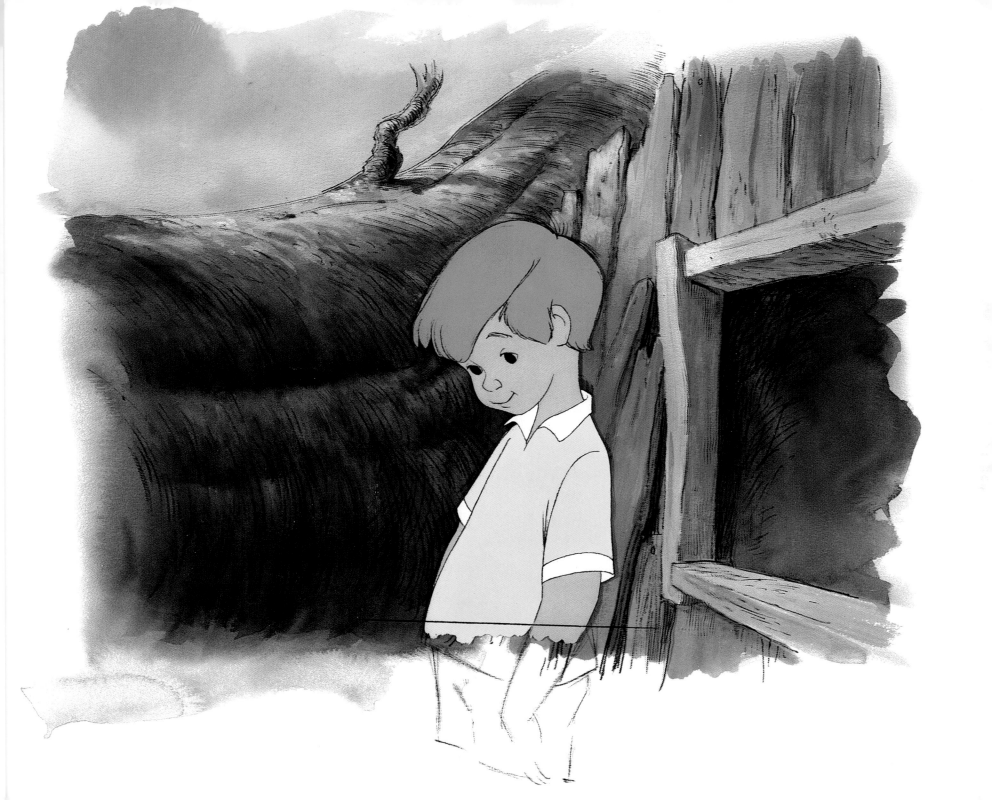

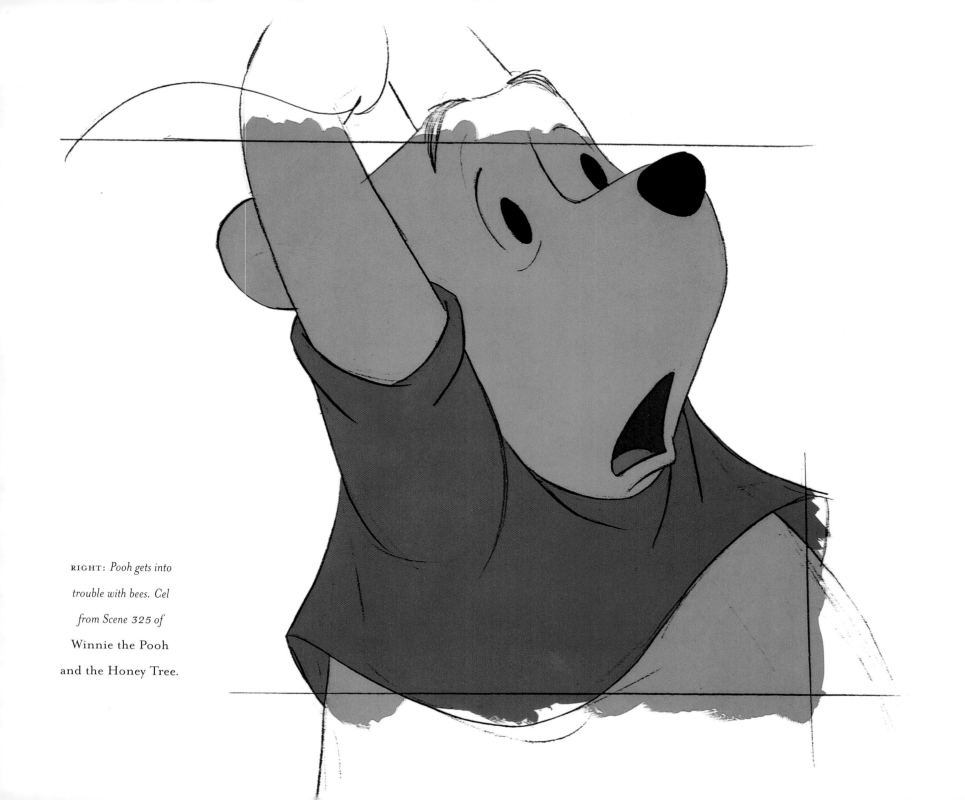

RIGHT: *Pooh gets into trouble with bees. Cel from Scene 325 of* Winnie the Pooh and the Honey Tree.

WINNIE THE POOH

Walt Disney's reinvention of Pooh started with the voice. This was provided by Sterling Holloway, whose reedy and querulous delivery was used to good effect in other Disney movies. Pooh is characteristically absent-minded, and Holloway delivered Pooh's lines with a hesitancy that suggested a muddled and bemused mind.

Animating Pooh was no easy task. Ernest Shepard had drawn him

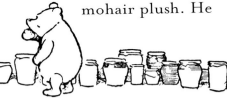

with a subtlety of outline that depended upon exploiting the illusion that Pooh is made from mohair plush. He used broken lines to suggest the condition of Pooh's "fur" when it is wet, or when it is sticky from honey. To attempt to reproduce this on screen might not have been impossible, but it would certainly have been impractical. Furthermore,

Pooh is a stuffed animal, and animators had to remain faithful to this concept while giving him some flexibility of movement.

In the end, the character designers devised a Pooh with a continuous outline, who wore a red T-shirt (which meant there was less fur texture to deal with). They also gave him thumbs when needed and added a hint of knee joints to his legs to allow for more convincing movement.

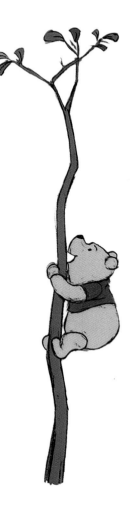

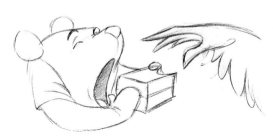

PIGLET

TOP CENTER: *Ernest H. Shepard illustration from page 114 of* Winnie-the-Pooh.

BELOW: *Concept art for* Winnie the Pooh and the Blustery Day.

Now Piglet lived in the middle of the forest in a very grand house in the middle of a and the Piglet loved his house very much. Next to his house was a piece of broken board which had "TRESPASSERS W" on it. When he was asked what it meant, he said it was his grandfather's name,

Shaped like a peanut on legs, with large pink ears—like folded breast-pocket handkerchiefs—and a chopped-off snout, Piglet must have been a delight to animate (as is evident from the scenes drawn by Ollie Johnston and Frank Thomas for *Winnie the Pooh and the Blustery Day*). He is very small, about half of Pooh's height, and maybe a tenth of Pooh's weight, easily susceptible to being blown away by brisk southwest winds.

Piglet was translated from the page to the screen almost without alteration. From his fastidious movements and his occasionally stuttering voice, we sense his rather complex character—nervous and anxious to please, yet loyal and even brave, in a timid sort of way. His "Oh, dear, oh, de-de-de-de-dear, dear" and tearful wringing of hands, even as he unselfishly offers his beloved house to the homeless Owl, shows how even such a small animal can be b-b-brave.

BELOW: *Model sheet from* Winnie the Pooh and the Blustery Day.

OPPOSITE: *Piglet follows the mysterious tracks on the snow with Pooh. Cel from Scene 352 of* Winnie the Pooh and Tigger Too.

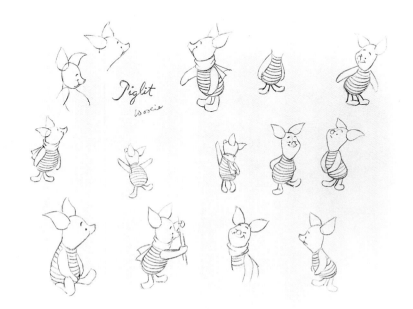

Piglit Woozie

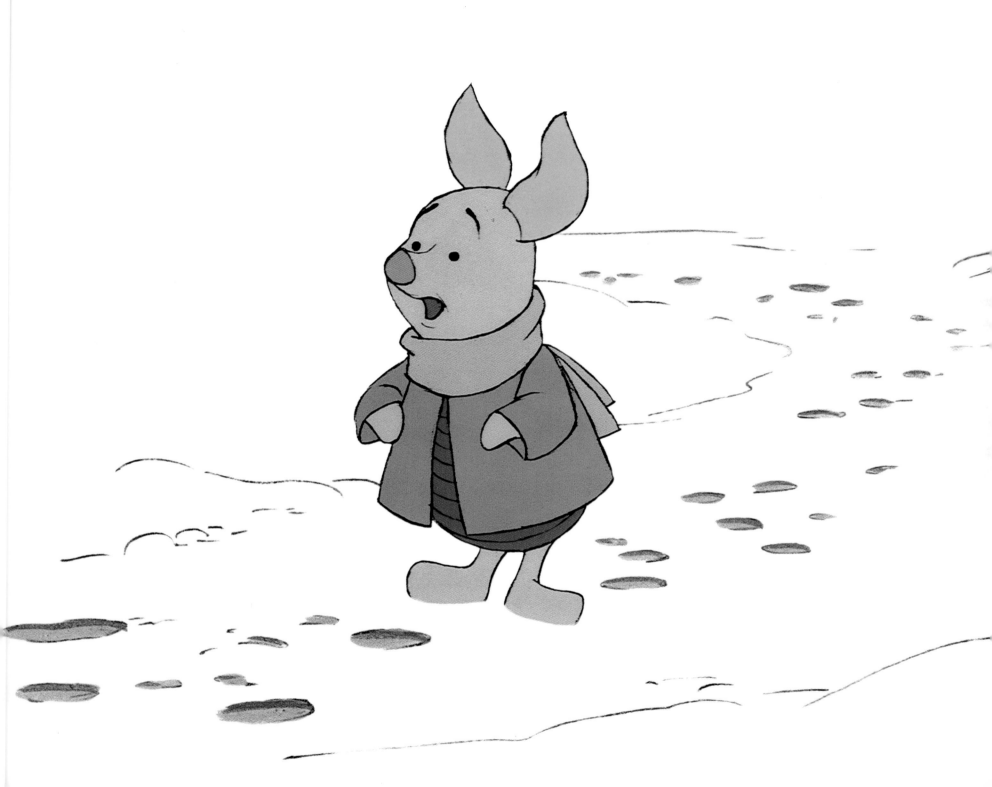

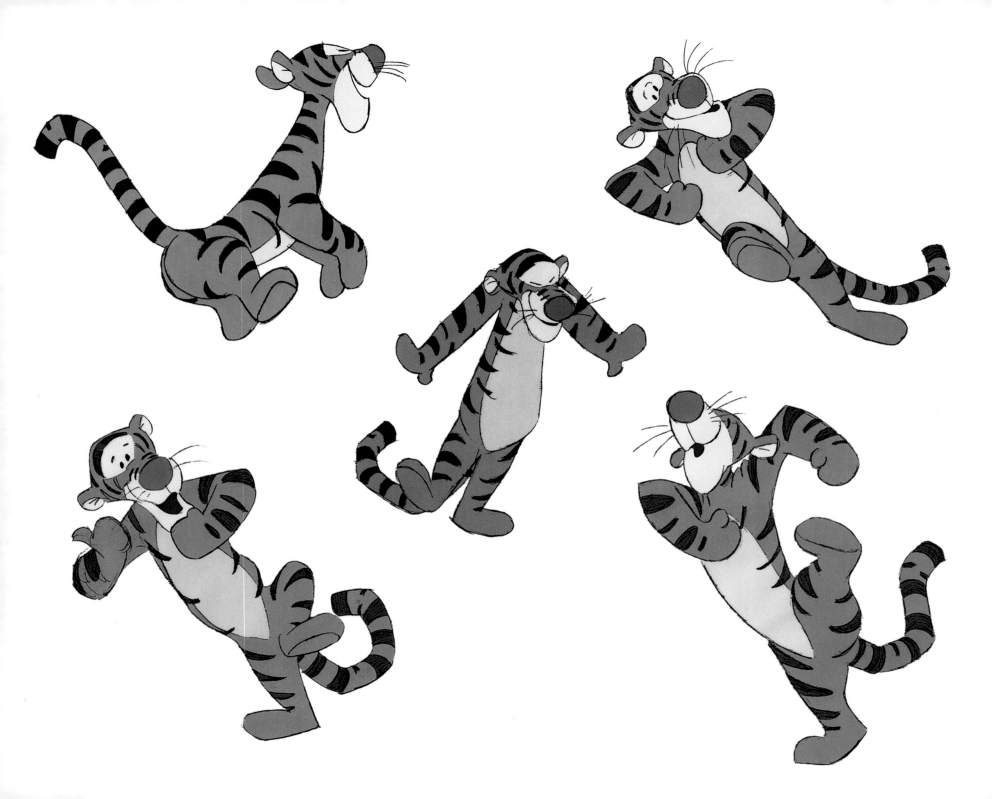

TIGGER

OPPOSITE: *Tigger expounds upon "the wonderful thing about tiggers." Cels from Scene 217 of* Winnie the Pooh and the Blustery Day.

Disney's Tigger must be judged an unqualified triumph—arguably more convincing on screen than in the Milne books. His hyperactive personality makes him a perfect character for animation, and he had the good fortune to be assigned, in his first screen appearance, to the great Milt Kahl, who endowed him with a level of kinetic energy that gave him the potential to steal any scene he appeared in.

With "those beady little eyes and that proposti-rus chin ... and those ricky-diculous striped pajamas," Tigger could hardly miss.

Add to all this the dimension provided by Paul Winchell's outlandish voice talent and you have all the ingredients for a major cartoon star.

LEFT: *Ernest H. Shepard illustration from page 127 of* The House at Pooh Corner.

BELOW: *Tigger faces the grim reality of a life without bouncing. Animation from Scene 506 of* Winnie the Pooh and Tigger Too *by John Pomeroy.*

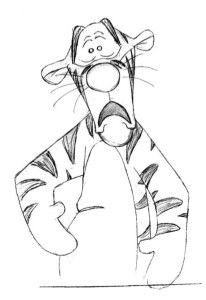
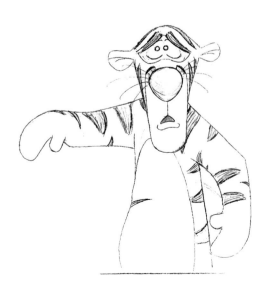

RABBIT

CENTER: *Ernest H. Shepard illustration from page 75 of* The House at Pooh Corner.

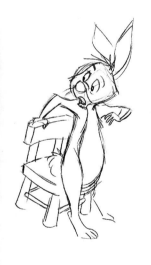

ABOVE & RIGHT: *Rough animation from* Winnie the Pooh and the Honey Tree.

At first glance, the on-screen Rabbit looks like the Rabbit of the books. He is presented somewhat realistically (more so, for example, than Thumper in the supposedly more naturalistic *Bambi*). On closer inspection, however, it will be seen that the Disney version of Rabbit has far more expressive features as well as quasi-human hands instead of paws. His face, in fact, has been deliberately caricatured so that he has become capable of the kind of close-up "takes" that are so useful to animators. Similarly, that his paws have become hands means that he is able to gesture more effectively and to grasp objects without seeming awkward. Matched to the voice of Junius Matthews, Rabbit is an example of a character who has been "Disneyfied" without completely losing touch with the model from which he had been adapted.

OPPOSITE: *Rabbit is lost in the mist and overcome by fear. Cel setup from Scene 177 of* Winnie the Pooh and Tigger Too.

72

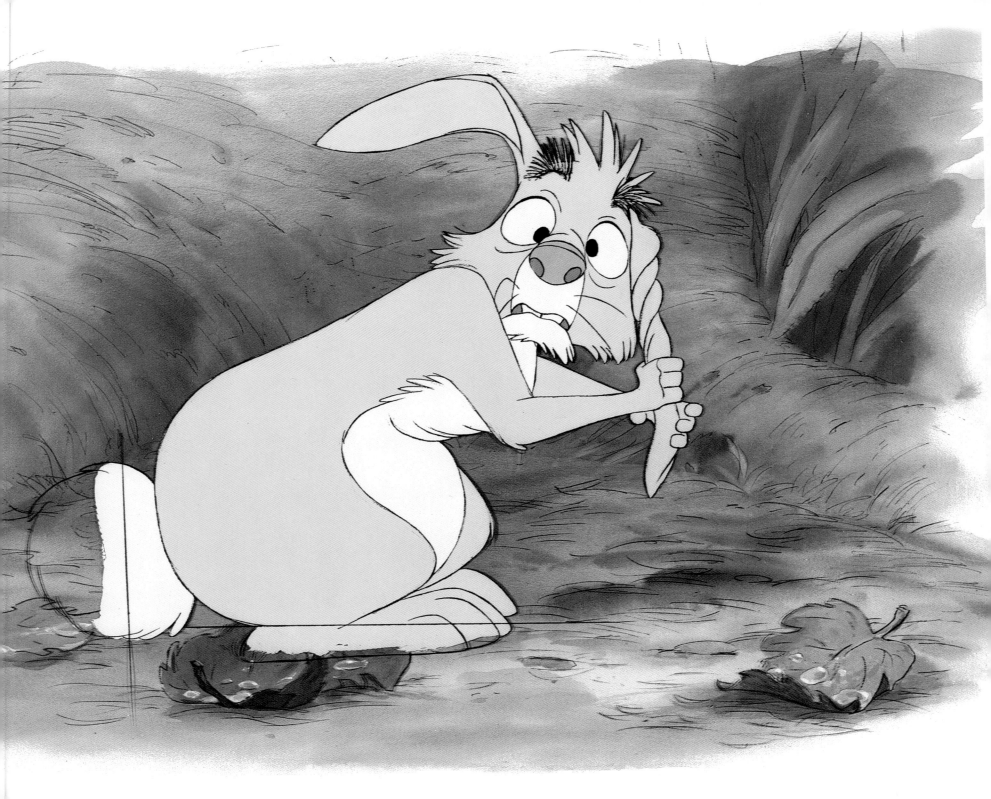

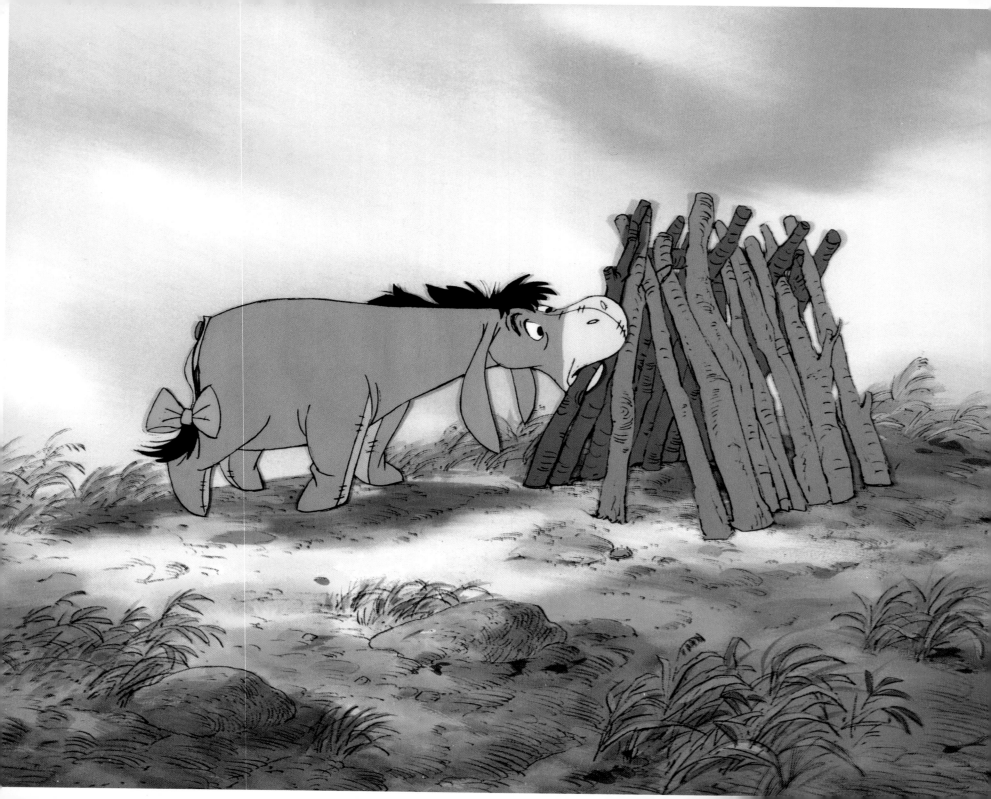

EEYORE

Eeyore, the doleful donkey, was a relatively simple character for animators to work with. His gloomy, head-hung-low stance is so visually expressive it might have been designed for the medium, and so the Shepard model could be adapted for the screen with very little modification. It was crucial, however, to cast the right voice to bring Eeyore to life. Ralph Wright was able to provide that, striking exactly the proper dejected note as he sighed signature phrases such as "No matter" and "Thanks for noticing me." If there is one fault to be found with Eeyore in the Disney featurettes, it is that he was not used enough.

OPPOSITE: *Eeyore builds his house of sticks. Cel setup from Scene 41 of* Winnie the Pooh and the Blustery Day.

LEFT: *Ernest H. Shepard illustrations from pages 46 & 47 of* Winnie-the-Pooh.

BELOW: *Model sheet drawing from* Winnie the Pooh and the Honey Tree.

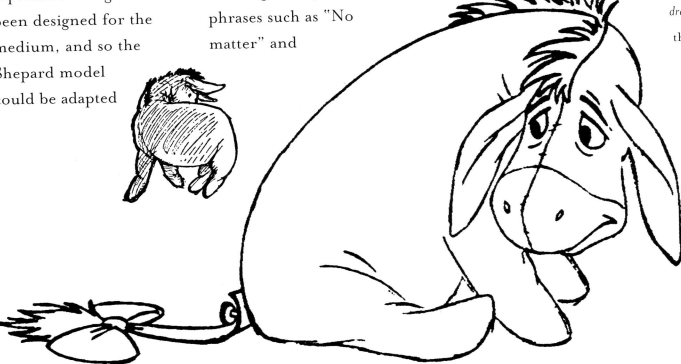

75

KANGA & ROO

When A. A. Milne began writing the Pooh stories, he worked primarily with his son's existing toys. Later he decided that more characters were needed to flesh out the cast. These included Tigger, Kanga, and Roo, whom Milne and his wife found and "adopted" on visits to the toy department at Harrods.

Tigger's entry into Pooh's world is nothing if not dramatic. Kanga and Roo arrive on the scene far more quietly, and this is appropriate since Kanga is the gentlest of creatures, an archetypal example of maternal instinct. As with Piglet and Eeyore, it was possible to adapt Kanga to the screen with little change from the Shepard version. The same is true of her son, Roo, who—being bouncy by nature—is able to serve as a playmate to the irrepressible Tigger.

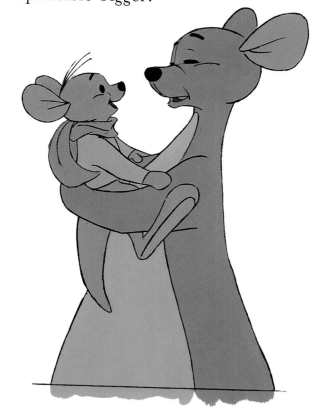

THE CHARACTERS ARE PRESENTED

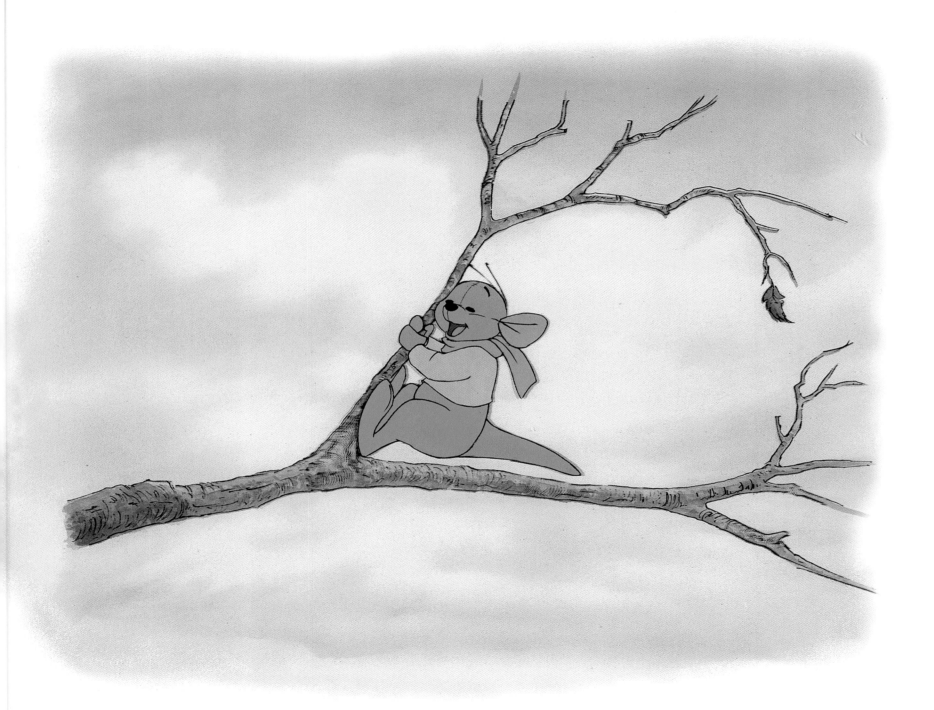

OWL

CENTER: *Ernest H.*
Shepard illustration
from page 157 of
The House at
Pooh Corner.

BELOW: *Rough anima-*
tion from Scene 58 of
Winnie the Pooh
and the Blustery
Day *by John Lounsbery.*

From the *Silly Symphonies* onward, Disney animated films have made frequent use of owls. The version found in the Pooh movies is very much in the studio's classic tradition, though his behavior is of course determined by the prototype found in the pages of the Milne books. Owl is not as wise as he is supposed to be, and cannot spell too well. All the same, he likes to use long words and to deliver grandiloquent speeches.

Because of this, when Owl is on screen the humor tends to be verbal. Still, Disney animators have done a fine job of bringing him fully to life. His face is especially expressive, capable of shifting from pomposity to panic in the blink of an eye.

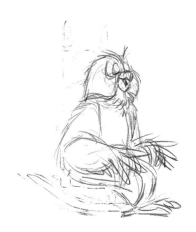

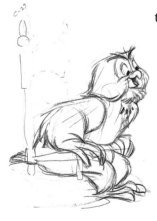

BELOW: *Owl delivers*
another long monologue.
Cel from Winnie the
Pooh and the
Honey Tree.

78

THE CHARACTERS ARE PRESENTED

GOPHER

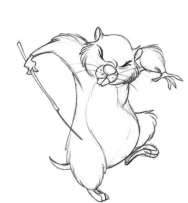

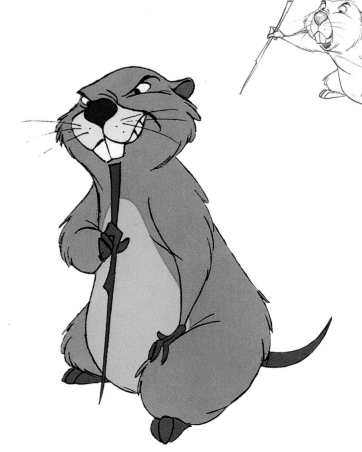

Gopher does not appear in the Milne books, and apparently it was Walt Disney who insisted on introducing him into the scenario of *Winnie the Pooh and the Honey Tree*, presumably to add an American touch to the story. Since Gopher is not a Milne character, animators had free reign.

Gopher is simply a blue-gray handyman who whistles through his buck teeth and shows up in rare moments to tell the audience he is not in the books.

BELOW: *Gopher estimates the cost for digging Pooh out of Rabbit's door. Cel and animation from* Winnie the Pooh and the Honey Tree *by John Lounsbery.*

CHAPTER FOUR

In Which

The Films Are Presented

WINNIE THE POOH AND THE HONEY TREE

WINNIE THE POOH AND THE BLUSTERY DAY

WINNIE THE POOH AND TIGGER TOO

WINNIE THE POOH AND A DAY FOR EEYORE

LEFT: *Concept art for* Winnie the Pooh and the Honey Tree.

WINNIE THE POOH AND THE HONEY TREE

In a comfortable hollow tree, deep in the Hundred-Acre Wood, lives a plump little bear of very little brain named Winnie the Pooh. As our story begins, Pooh is reminded by his "pooh-coo clock" that the hour has arrived for something important to take place. But what? Memory is not Pooh's strong suit. Finally, though, he recalls that it's time for his stoutness exercises. Having performed these to the best of his limited ability, he finds himself subjected to a severe case of peckishness. Only one thing can completely cure a major hunger attack—a sizable serving of his favorite food, honey. He removes his last honeypot from its cupboard and sticks his nose inside. Empty! Pooh cannot believe his bad luck, but hearing the buzz of a bee, he quickly perks up. His brain may be modestly endowed, but he knows that where there's a bee then a treasure trove of honey cannot be far away.

Pooh follows the bee to a tall oak tree where other busy insects are buzzing around a hole in the trunk. Pooh has hit the jackpot. Raw honey! Without pausing, he shins up the tree and, in an attempt to reach the precious, golden syrup, entrusts his considerable weight to a much too slender bough. It snaps and Pooh falls into a prickly gorse bush.

Now Pooh decides to seek the help of his friend Christopher Robin, who lives conveniently nearby. He finds him in the company of other denizens of the Hundred-Acre Wood: Kanga and her son Roo, along with Rabbit and Owl. They are trying to pin the tail back on Eeyore the donkey. (Eeyore is in the habit of losing his tail from time to time.) Pooh interrupts this important task to ask if Christopher Robin has a sky-blue balloon he can borrow. Christopher Robin lends him one, and together they return to the honey tree where—after rolling in a mudhole to disguise himself as a rain cloud—Pooh is carried upward by the balloon toward the enticing cache of honey.

The bees are not entirely fooled by Pooh's disguise. They are, in fact, decidedly suspicious. But Pooh persists, persuading Christopher Robin to fetch an umbrella and walk up and down under the tree saying, "Tut-tut, it looks like rain." This ruse permits Pooh to

come close enough to the honey to scoop a little into his mouth, but it is laced with angry bees and he is forced to spit it out. Other bees attack the balloon. It loses air rapidly so that Pooh comes tumbling down once more, on top of Christopher Robin this time. With a swarm of vengeful bees in pursuit, Pooh and his friend escape by diving into the mud-pool and taking shelter beneath the umbrella.

Hungrier than ever, Pooh heads for Rabbit's house. Suspecting that Pooh's visit has more to do with food than friendship, Rabbit claims not to be home. Not taken in by this pretense, Pooh wangles an invitation to lunch and proceeds to devour all of Rabbit's condensed milk and honey. Satisfied that nothing is left, Pooh thanks his flabbergasted host and heads for the exit. But he has eaten too much and is unable to squeeze through the doorway. Soon it becomes apparent that he is stuck.

As hard as Rabbit pushes, he cannot budge Pooh. In response to Rabbit's request for help, Christopher Robin arrives on the scene with Eeyore, Owl, Gopher, Kanga, and Roo in tow. The only solution to the problem, Christopher Robin suggests, is to leave Pooh where he is until he has lost enough weight to be pulled free. This leaves Rabbit to make

the best of having Pooh's bottom on extended loan in his living room. Rabbit's attempts to decorate the offensive rear end are largely unsatisfactory.

Days and nights pass without Pooh being able to move so much as an inch. He is starving, of course, and almost manages to persuade Gopher to feed him a smidgen of honey. Rabbit, panicked, intervenes in the nick of time and erects a sign that reads DON'T FEED THE BEAR!

Rabbit begins to think that Pooh will be part of the furnishings forever. One morning, however, the long-suffering homeowner leans against the chubby bear's hindquarters and finally Pooh begins to budge. Christopher Robin and the others are called, and after much pushing and pulling, Pooh pops free, like a cork from a bottle. Sailing through the air, he flies headfirst toward another opening, this time a hole in a tree. Worried that Pooh has become stuck again, his friends hurry to the spot, only to find him in a state of ecstasy.

The hole is in a honey tree and bears love honey.

NARRATOR: **"Winnie the Pooh lived in this enchanted forest under the name of 'Sanders' ..."**

THE FILMS ARE PRESENTED: WINNIE THE POOH AND THE HONEY TREE

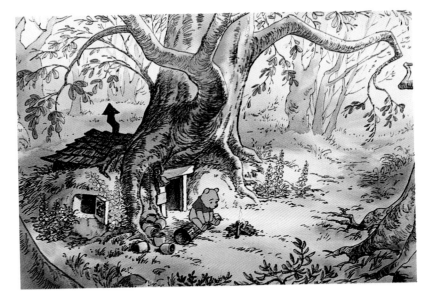

ABOVE: *Pooh in front of his home. Cel setup from Scene 5.*

LEFT: *The enchanted neighborhood of Christopher Robin's childhood days. Concept art.*

POOH: "I am stout, round, and I have found, speaking poundage-wise,
I improve my appetite when I exercise!"

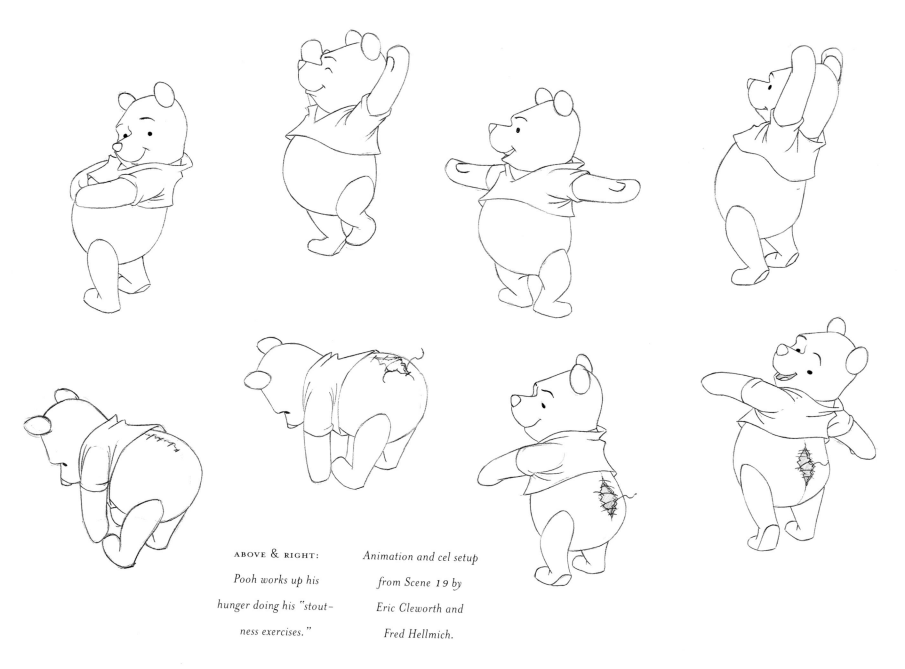

ABOVE & RIGHT:
Pooh works up his
hunger doing his "stout-
ness exercises."

Animation and cel setup
from Scene 19 by
Eric Cleworth and
Fred Hellmich.

THE FILMS ARE PRESENTED: WINNIE THE POOH AND THE HONEY TREE

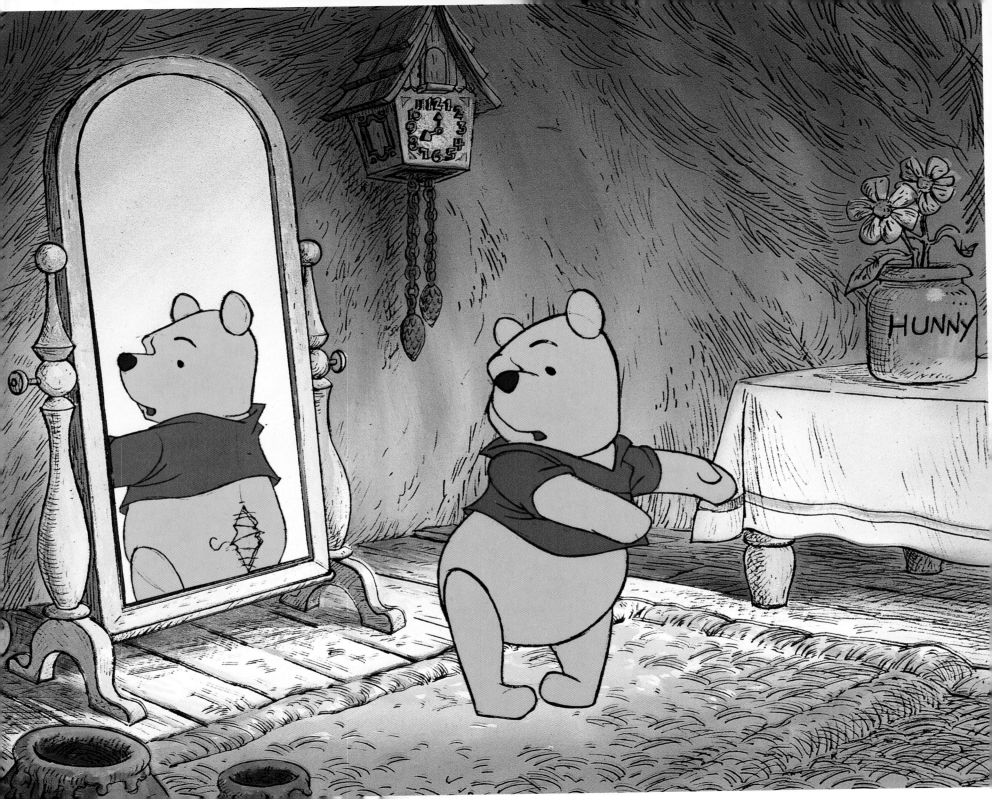

POOH: "Oh bother, empty again—
only the sticky part's left . . ."

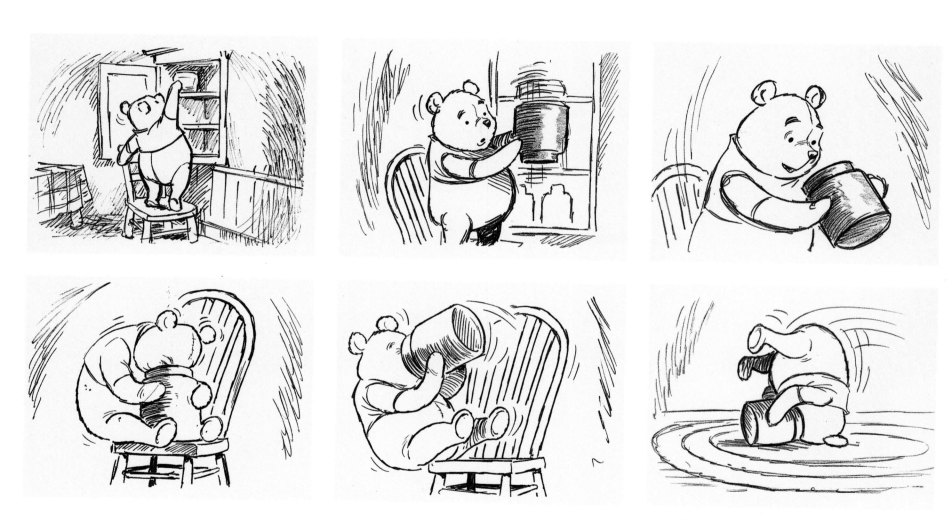

THE FILMS ARE PRESENTED: WINNIE THE POOH AND THE HONEY TREE

POOH: **"That buzzing noise means something. And the only reason for making a buzzing noise that I know of is because you are a bee!"**

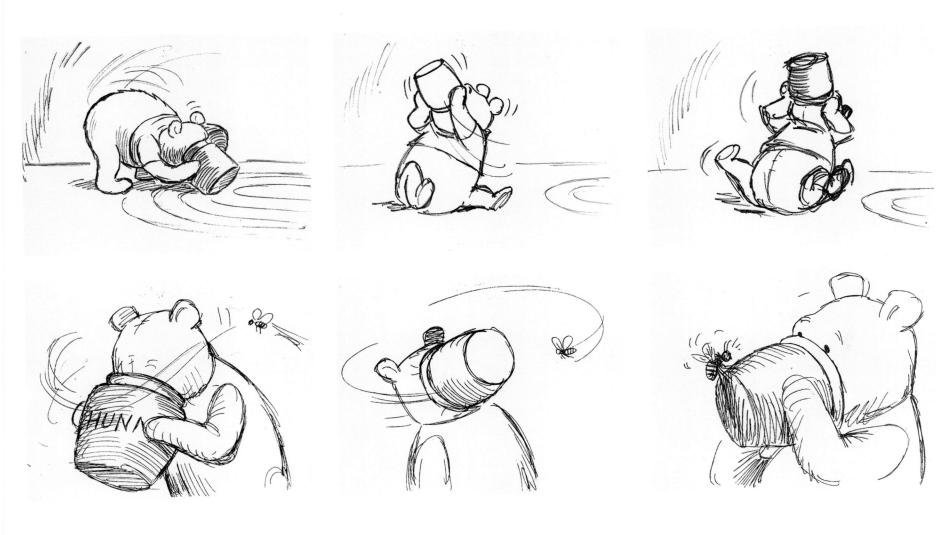

ABOVE & OPPOSITE:

Pooh searches for food but finds the honeypots empty. Storyboard art from Scenes 24 to 32.

POOH: "**Bears love honey and I'm a Pooh bear so I do care so I'll climb there, I'm so rumbly in my tumbly— time for something sweet . . .**"

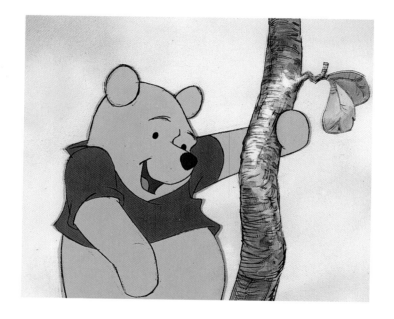

ABOVE & RIGHT: *Pooh climbs up the honey tree. Cel setup and cel from Scenes 39.3 and 41.*

OPPOSITE: *Pooh's quest for honey goes awry as he falls and lands in the prickly gorse bush. Cel setup from Scene 46.*

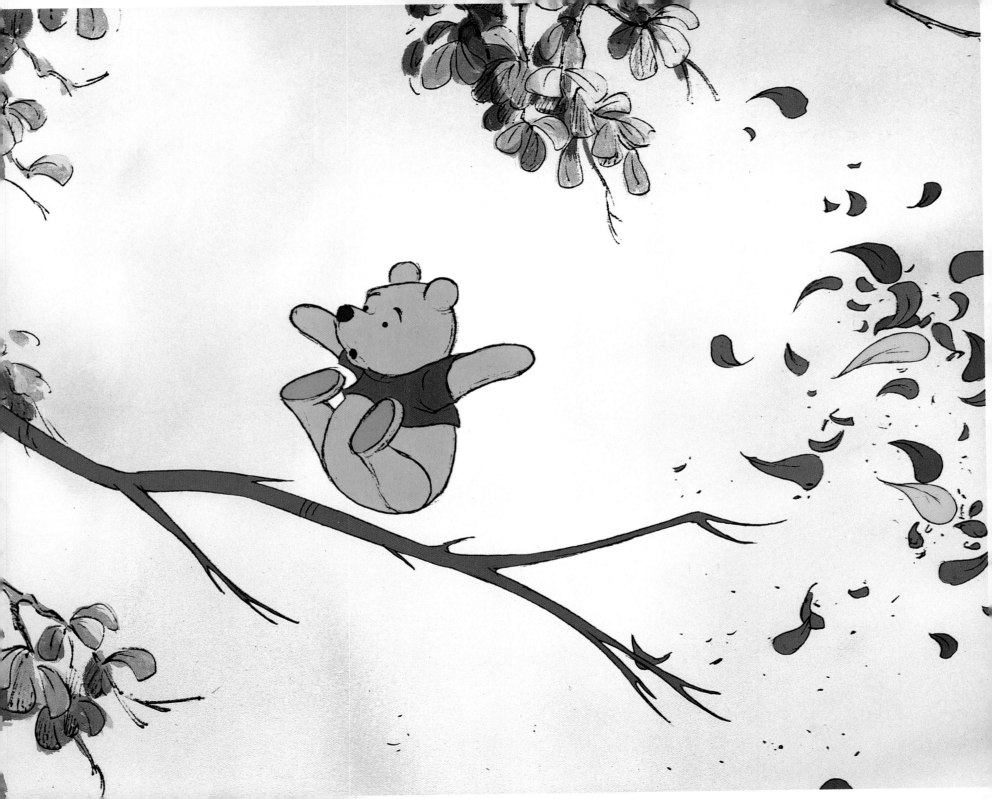

POOH: "Now would you aim me
at the bees . . . please."

THE FILMS ARE PRESENTED: WINNIE THE POOH AND THE HONEY TREE

THIS PAGE: *Pooh is found out by the bees. Concept art.*

OPPOSITE: *Pooh poses as a "little black rain cloud" in order to deceive the bees. Cel setup from Scene 301.9.*

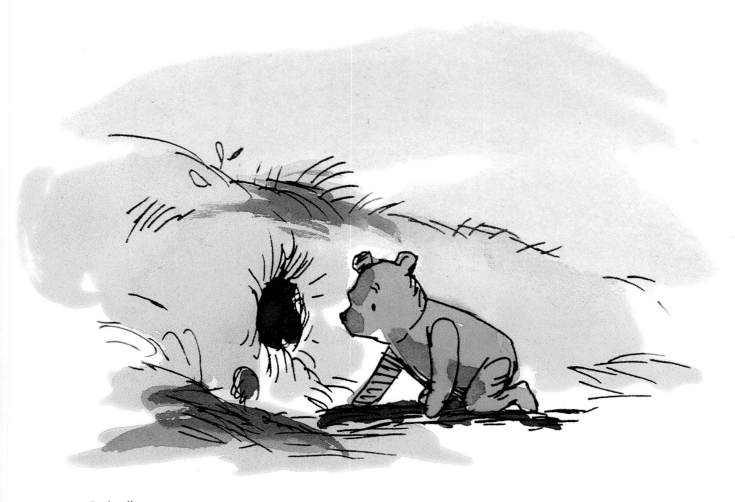

POOH: "Bother, isn't there anybody here at all?"

RABBIT: "Nobody!"

POOH: "Must be some-body there because somebody must have said 'nobody.' Rabbit . . . isn't that you?"

RABBIT: "No!"

ABOVE: *Pooh calls on Rabbit in hopes of a friendly snack. Concept art.*

OPPOSITE: *Rabbit attempts to get rid of his uninvited guest, the ever-hungry Pooh. Cel setup from Scene 403.*

LEFT: *Pooh eats Rabbit's entire stock of honey. Cel setup from Scene 415.*

RABBIT: "Oh dear—oh, gracious—oh well it all comes from eating too much!"

POOH: "It all comes from not having front doors big enough!"

 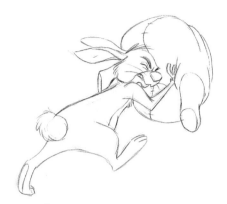

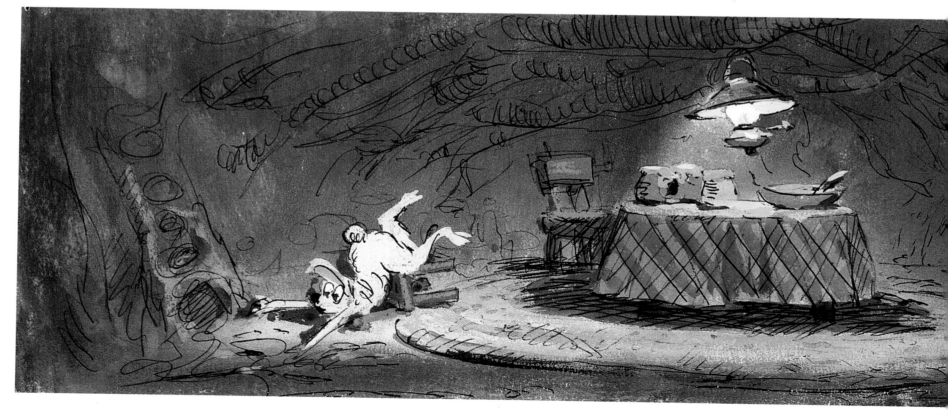

THE FILMS ARE PRESENTED: WINNIE THE POOH AND THE HONEY TREE

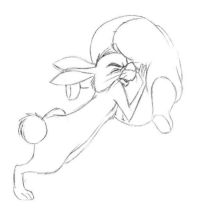

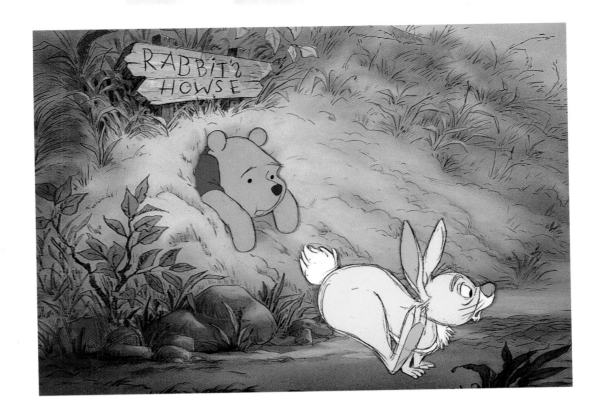

ABOVE LEFT: *Rabbit tries without luck to push Pooh out his door. Animation from Scene 422 by Hal Ambro.*

ABOVE: *A worried Rabbit runs for help. Cel setup from Scene 426.*

LEFT: *Rabbit tries to live with Pooh's south end. Concept art.*

RIGHT: *Christopher Robin comes to the rescue. Cel setup from Scene 522.*

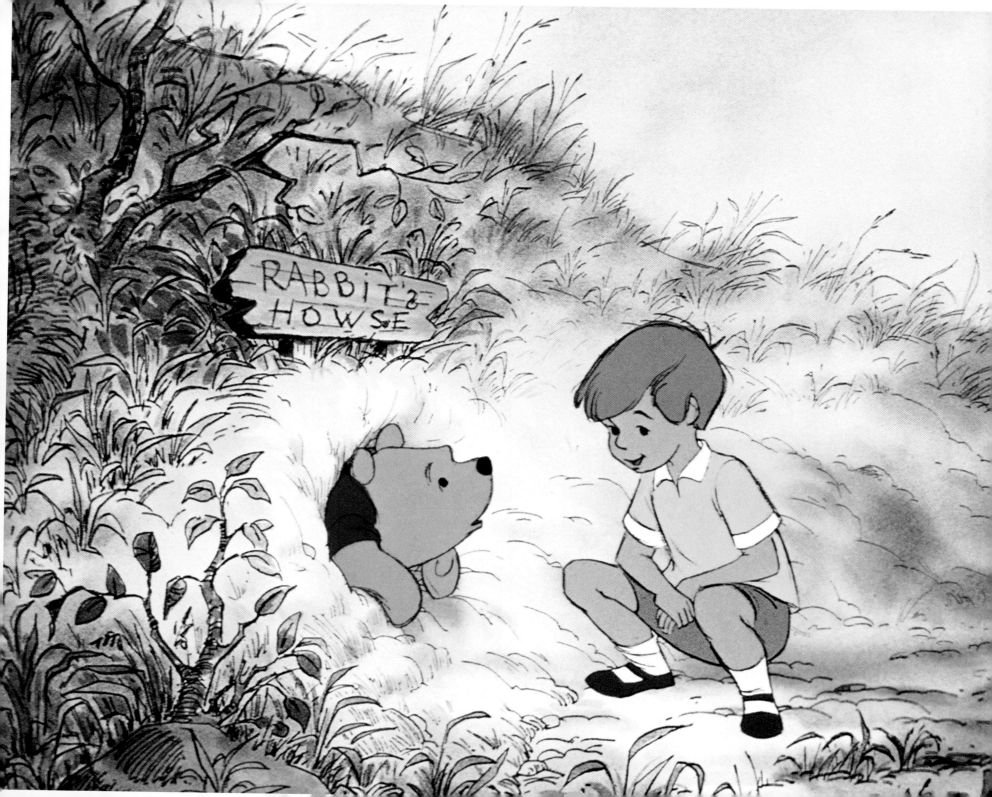

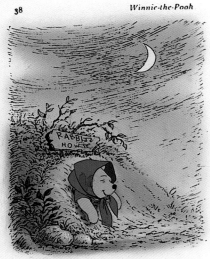

. . . night after lonely night . . .

For some time now Pooh had been saying "Yes"
and "No" in turn, with his eyes shut, to all that
Owl was saying, and having said, "Yes, yes," last
time, he said "No, not at all," now, without really

ABOVE: *Night after*
lonely night passes as
Pooh waits to become
thinner. Cel setup from
Scene 562.1.

OPPOSITE & RIGHT:
Christopher Robin
reassures Pooh and
keeps him company. Cel
setups from Scenes 526
and 562.1.

CHRISTOPHER ROBIN: **"Pooh Bear, there's only one thing we**
can do: wait for you to get thin again."

ABOVE: *Pooh's friends*
celebrate when the bear is
thin enough to budge.
Storyboard art from
Scene 626.

101

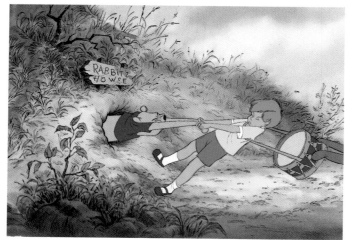

RABBIT: "Hah! There he goes!"

THIS PAGE: *Pooh finally
loses enough weight to be
tugged free. Animation
and cel setups from Scene
637 by Walt Stanchfield.*

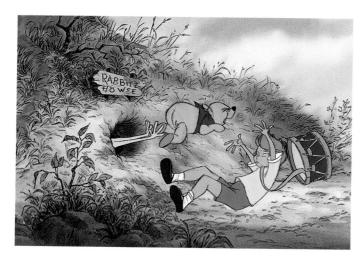

OPPOSITE: *Pooh sails
out of Rabbit's hole into
another hole—this time
to his glee! Cel setup
from Scene 650.*

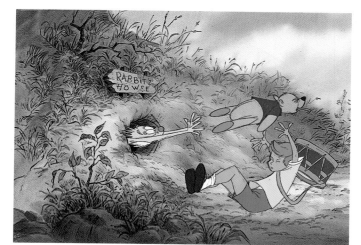

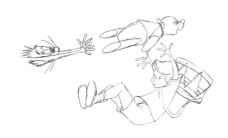

102

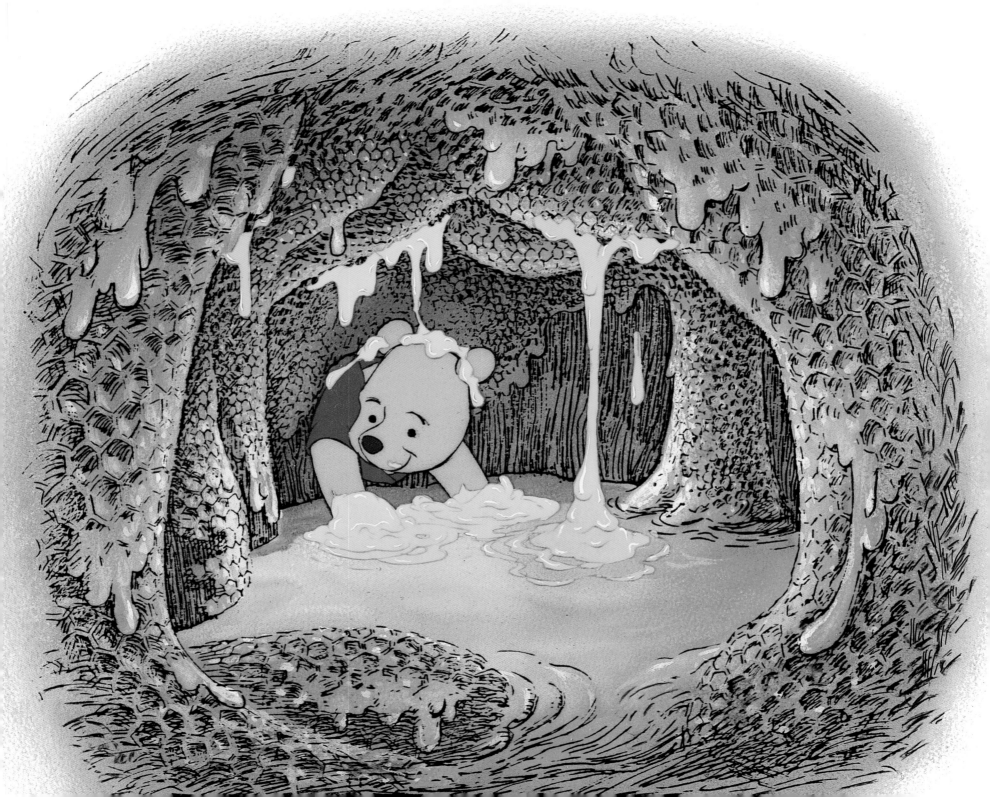

WINNIE THE POOH AND THE BLUSTERY DAY

When the East Wind trades places with the West Wind, things are stirred up in the Hundred-Acre Wood. On this particular blustery day, Pooh makes his way to his Thoughtful Spot to try some recreational thinking, even though thinking is not easy for a bear of small brain. Pooh is hard at it when Gopher appears and asks what he is thinking about. Pooh can't remember. Gopher warns him that it is Windsday. That gives Pooh an idea. He will visit everyone and wish them a happy Windsday.

First he calls on his dear friend Piglet, who lives in the depths of the forest in a rather grand house in a beech tree. Piglet is sweeping leaves from the pathway that leads to his door, but on this annoyingly blustery day the leaves keep blowing back again. Determined to be cheerful, Pooh calls out, "Happy Windsday." Piglet says he doesn't see anything to be happy about since the wind is threatening to blow him away. As Piglet speaks, in fact, a fierce gust forces him to backpedal helplessly. A large leaf almost knocks him over, and then, acting as a sail, pushes him faster. In an effort to save his friend, Pooh grabs Piglet's scarf, but it begins to unravel, so that Pooh is left holding a single strand of wool as Piglet is swept into the air. Tossed this way and that by the wind, Piglet tries to grab on to passing trees but is carried higher and higher till his only contact with the earth is Pooh and the strand of wool that connects them.

Piglet sails over the house occupied by Kanga and Roo. Roo mistakes Piglet for a kite, which is exactly what he looks like, bucking and bobbing at the end of the thread. By now the wind has become so strong that Pooh has difficulty hanging on. He tries to dig his heels in, but that doesn't help. Instead he is dragged along, like a water-skier on dry land, and is pulled through a house that Eeyore has just finished building, utterly destroying it. ("Thanks for noticing me," says Eeyore dolefully.) He is then dragged through Rabbit's kitchen garden, inadvertently helping to harvest the carrots. Finally Pooh is swept off the ground too, and he and Piglet fly together until both are blown up against the window of Owl's house high in the branches of a big tree.

Owl lets them in. The tree bends with the gale and furniture slides around as Owl regales his guests with a long and pompous story about nothing in particular. The wind gets stronger and stronger until finally the tree that supports Owl's home is blown down. The house is smashed to pieces. Christopher Robin, arriving on the scene, offers the opinion that nothing can be done to repair it. Upon hearing this, Eeyore—although he has just lost his own house—generously announces that he will launch a search to find a new residence for Owl.

Blustery day becomes blustery night. Snug in bed, Pooh hears spooky noises. He opens his front door, hoping to find Christopher Robin or Piglet outside. Instead he is confronted by a creature he has never seen before—a striped, hyperkinetic character who bounces crazily into the air, sending Pooh sprawling, then lands on Pooh's ample stomach.

The chubby bear's breath is knocked out of him. When he is able to talk again, he admits to the stranger that he was scared. The creature introduces himself as Tigger and proudly acknowledges that everyone is afraid of Tiggers. As if to prove the point, he catches sight of his own reflection in Pooh's mirror and scares himself. Pooh calms his uninvited guest and graciously offers him a taste of honey. Tigger samples the honey and pronounces it disgusting—fit only for Heffalumps and Woozles. With that, Tigger bounces off into the night, leaving Pooh to worry about Heffalumps and Woozles, famous the world over, it seems, as unscrupulous honey bandits.

Pooh mounts guard over his precious honeypots, marching up and down in front of the mirror until exhaustion overcomes him and he falls asleep. Soon he is dreaming of Heffalumps and Woozles. They come in a wide variety of shapes, sizes, and colors—blue, black, pink, and brown. Some are striped, and some are covered with polka dots. All of them have a single ambition—to steal Pooh's honey. One of the Heffalumps turns into a watering can and begins to douse Pooh with water. Pooh wakes suddenly and finds that there is water everywhere. The blustery weather has blown in black clouds that have dumped several inches of rain on the Hundred-Acre Wood.

Many residents find their homes flooded. Piglet, for instance, discovers there is little he can do to stop the rising waters and climbs aboard a floating chair as he tries to bail out his living room. Abandoning this hopeless task, he manages to write a note requesting help, and just has time to place it in a bottle before he is swept away by the flood. Soon he finds himself

carried underneath a low-hanging bough where Pooh has taken refuge with his supply of honey. As Piglet drifts by, Pooh falls in too, his head now firmly stuck in a honeypot which keeps him afloat, his stubby legs waving in the air. Flying overhead, Owl spots them, but instead of attempting a rescue or going for aid, he delivers another of his endless homilies. He even fails to warn Pooh and Piglet that they are about to be swept over a waterfall.

As they go over the falls, Pooh somehow ends up on Piglet's chair and Piglet in Pooh's honeypot. Both are rescued and brought to dry land, safe and sound.

Except for Eeyore, who is still searching for a house for Owl, everyone else gathers at Christopher Robin's house, which is located above the flood line. Christopher Robin credits Pooh with saving Piglet and promises to throw him a hero party when the weather gets better.

On the day of the party, Christopher Robin, Piglet, Tigger, Rabbit, Owl, Kanga, and Roo gather together in Pooh's honor. Eeyore is still missing but soon arrives with the good news that he has found a house for Owl. Everyone follows Eeyore to see just what it is that he has turned up. In fact it's a very nice house. The problem is, it's Piglet's house. No one is quite sure how to point this out without causing Eeyore embarrassment. Even Piglet, though he's broken-hearted to lose his home, can't bear to humiliate Eeyore and disappoint Owl. Bravely and tearfully, Piglet relinquishes his house. But where will he live?

"With me, of course," Pooh insists.

Piglet happily accepts and the party continues. But now it is for two heroes, Piglet and Pooh.

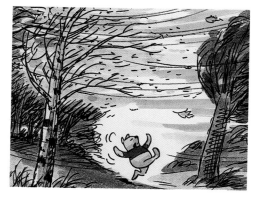

POOH: "Oh, the wind is lashing lustily, and the trees are thrashing thrustily, and the leaves are rustling gustily, so it's rather safe to say—that it seems that it may turn out to be—it feels that it will undoubtedly—it looks like a rather blustery day today."

THIS PAGE: Pooh revels in the blustery weather. Storyboard art from Scene 2.

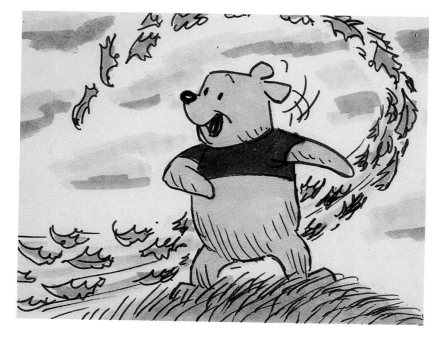

OPPOSITE: Pooh tries hard to "think of some-thing" at his Thoughtful Spot. Cel setup from Scene 5.

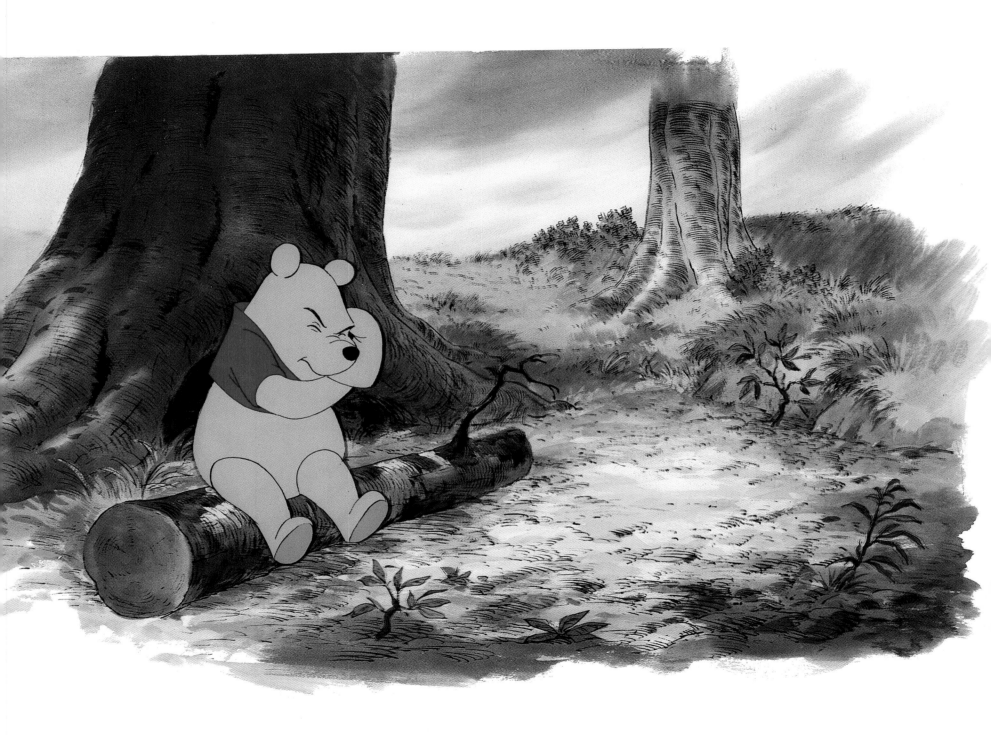

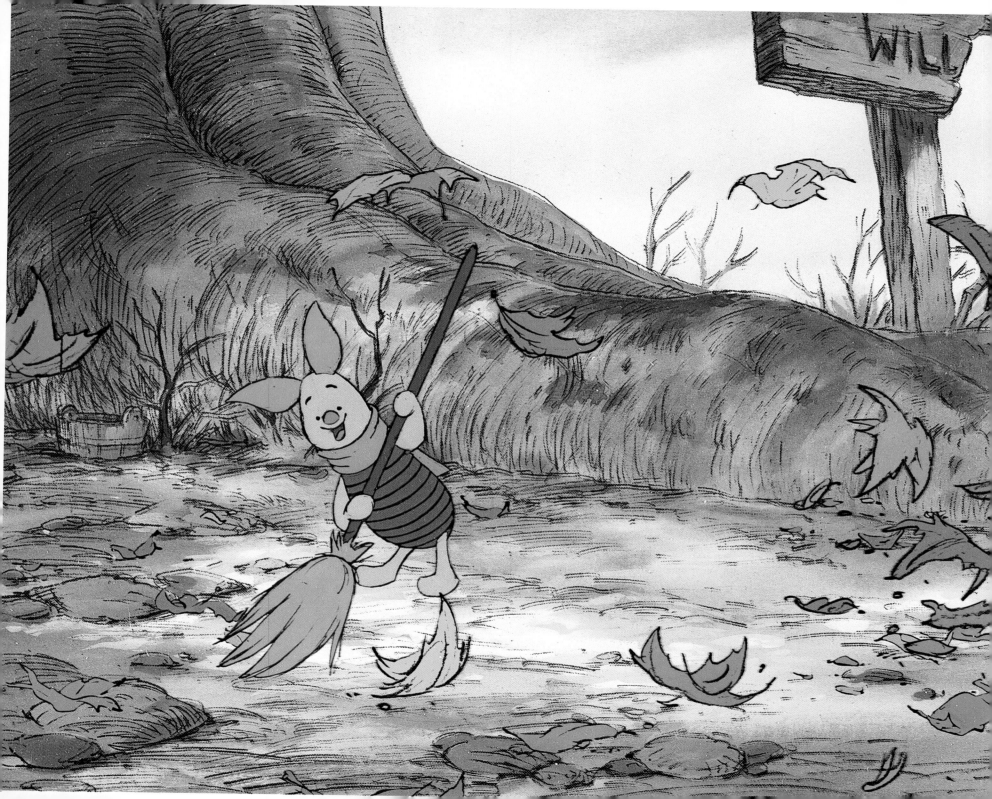

NARRATOR: "... And on this blustery day, the wind
was giving you a bit of a bother."

PIGLET: "I don't mind the leaves that are leaving.
It's the leaves that are coming ..."

ABOVE: *Piglet is swept away by a leaf. Animation from Scene 25 by Ollie Johnston.*

OPPOSITE: *Piglet sweeps the entranceway to his cherished home. Cel setup from Scene 20.*

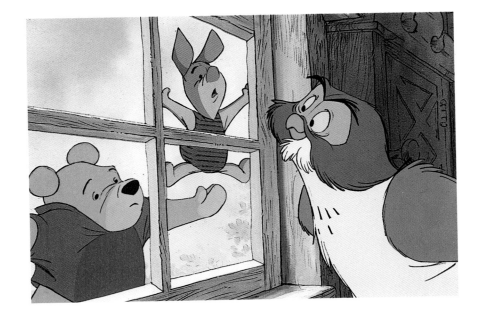

ABOVE: *The strong wind carries Piglet and Pooh to Owl's window. Cel setup from Scene 53.*

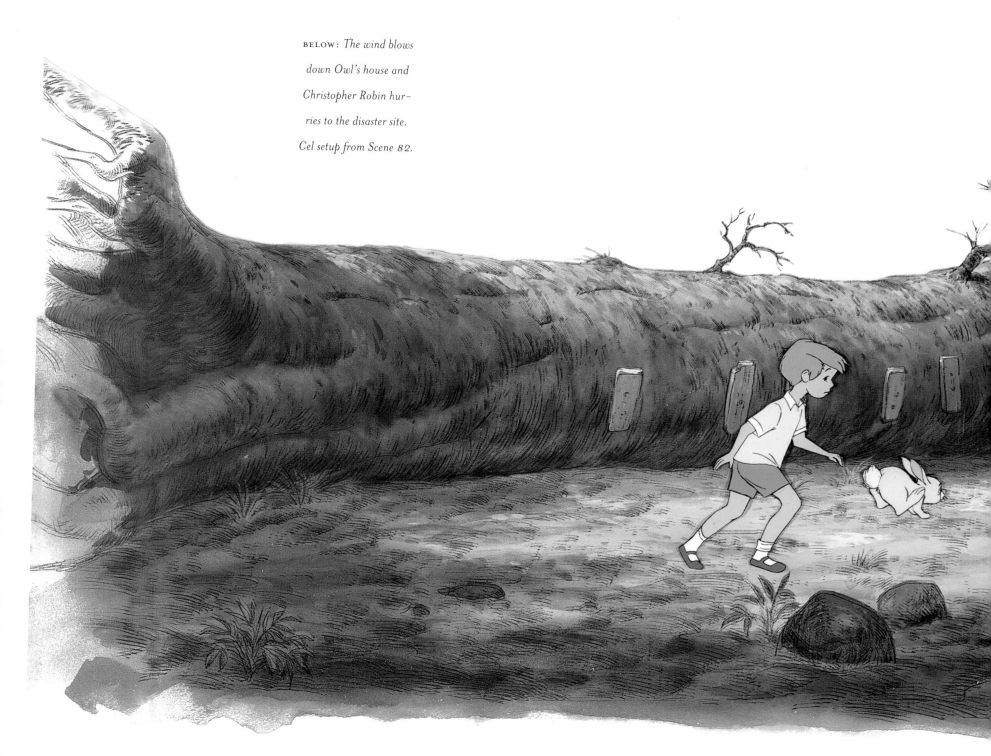

BELOW: *The wind blows down Owl's house and Christopher Robin hurries to the disaster site. Cel setup from Scene 82.*

THE FILMS ARE PRESENTED: WINNIE THE POOH AND THE BLUSTERY DAY

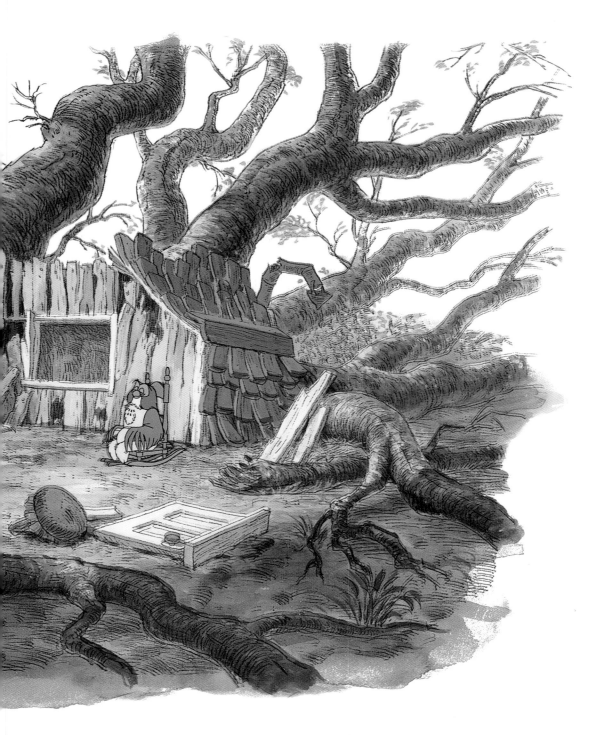

CHRISTOPHER ROBIN: "What a pity. Owl, I don't think we will ever be able to fix it."

EEYORE: "If you ask me, when a house looks like that, it's time to find a new one."

CHRISTOPHER ROBIN: "That's a very good idea, Eeyore."

EEYORE: "Might take a day or two but I'll find a new one."

OWL: "Good, that will just give me time to tell you about my Uncle Clyde . . ."

said, "What I like best in the whole world is Me and Piglet going to see You, and You saying 'What about a little something?' The day was all blustery and windy outside and it was all cozy and warm inside Pooh's house.

The blustery day turned into a blustery night. To Pooh it was a very anxious sort of night, filled with anxious sorts of noises. One of the noises was a sound that had never been heard before.

"That noise means something. And just might

said, "What I like best in the whole world is Me and Piglet going to see You, and You saying 'What about a little something?' The day was all blustery and windy outside and it was all cozy and warm inside Pooh's house.

The blustery day turned into a blustery night. To Pooh it was a very anxious sort of night, filled with anxious sorts of noises. One of the noises was a sound that had never been heard before.

"That noise means something. And just might

LEFT: The blustery day turns into a blustery night. Cel setups from Scene 201.

BELOW: Pooh hears a sound that he has never heard before outside his window. Cel setup from Scene 205.

OPPOSITE: Pooh opens his door slightly and is knocked over by a strange creature. Cel setup from Scene 207.

NARRATOR: **"Owl talked from page forty-one to page sixty-two, and on page sixty-two the blustery day turned into a blustery night. To Pooh it was a very anxious sort of a night . . ."**

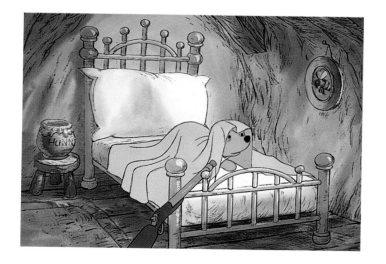

THE FILMS ARE PRESENTED: WINNIE THE POOH AND THE BLUSTERY DAY

TIGGER: "Tiggers don't like honey."

POOH: "But you said that you liked . . ."

TIGGER: "Yeah, that icky, sticky stuff is only fit for Heffalumps and Woozles."

ABOVE: *Tigger shows his distaste for the honey Pooh offered. Cel setup from Scene 234.*

RIGHT: *Having warned Pooh about Heffalumps and Woozles and their honey-stealing ways, Tigger makes his exit. Cel setup from Scene 244.*

THE FILMS ARE PRESENTED: WINNIE THE POOH AND THE BLUSTERY DAY

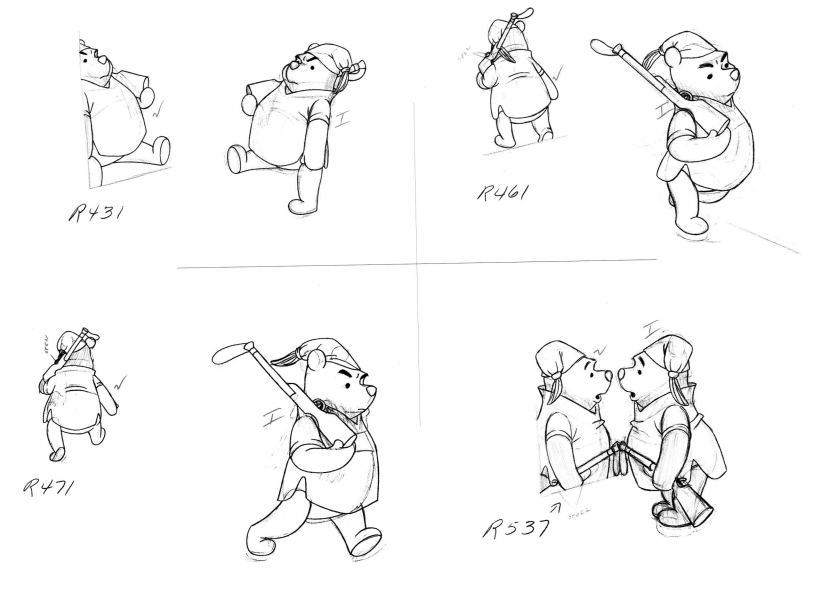

R431

R461

R471

R537

THIS PAGE: *Pooh and his reflection guard their honey from Heffalumps and Woozles. Animation from Scene 97 by Hal King.*

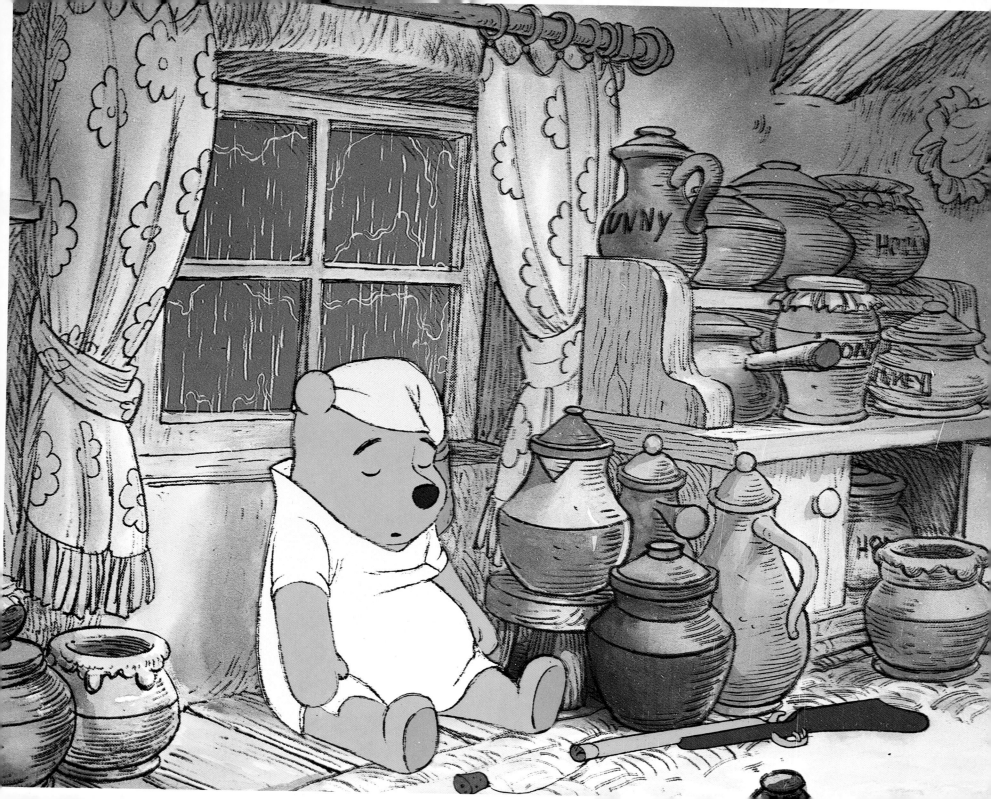

THE HONEYPOTS: "They're far, they're near,
they're gone, they're here.
They're quick and slick, they're insincere.
Beware! Beware! Be a very wary bear."

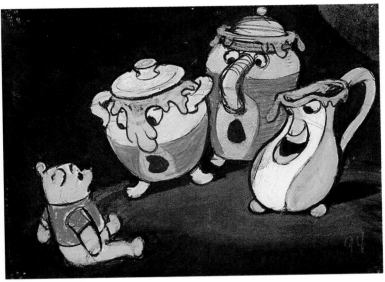

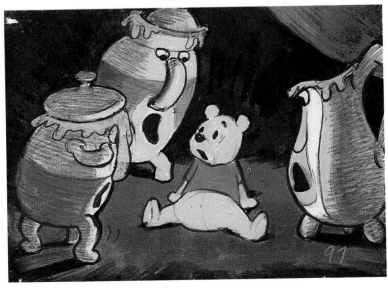

OPPOSITE: *Tired from
his sentry duty, Pooh falls
asleep and dreams. Cel
setup from Scene 100.*

THIS PAGE: *Honeypots
surround and warn Pooh
about Heffalumps and
Woozles. Storyboard art
from Scene 100.*

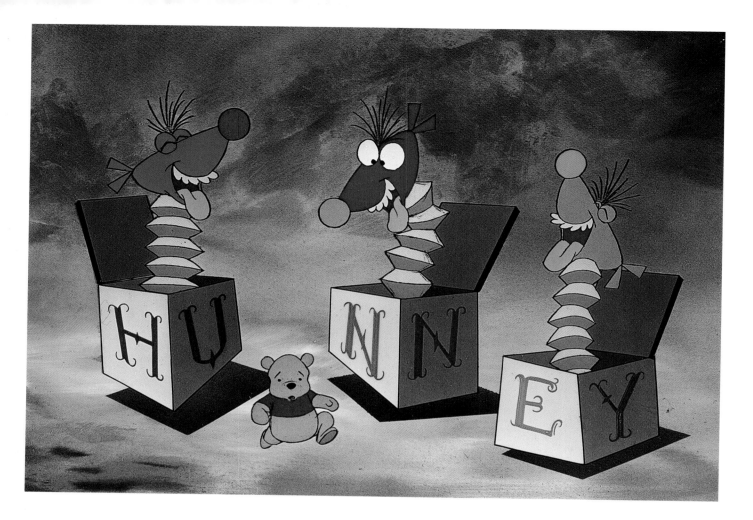

THESE PAGES:

Heffalumps and Woozles
of every shape, size,
and color haunt Pooh.
Cels and cel setups from
Scenes 101 to 121.

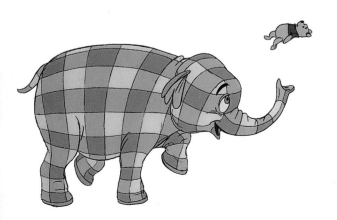

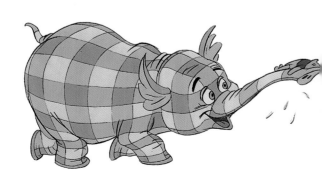

THE FILMS ARE PRESENTED: WINNIE THE POOH AND THE BLUSTERY DAY

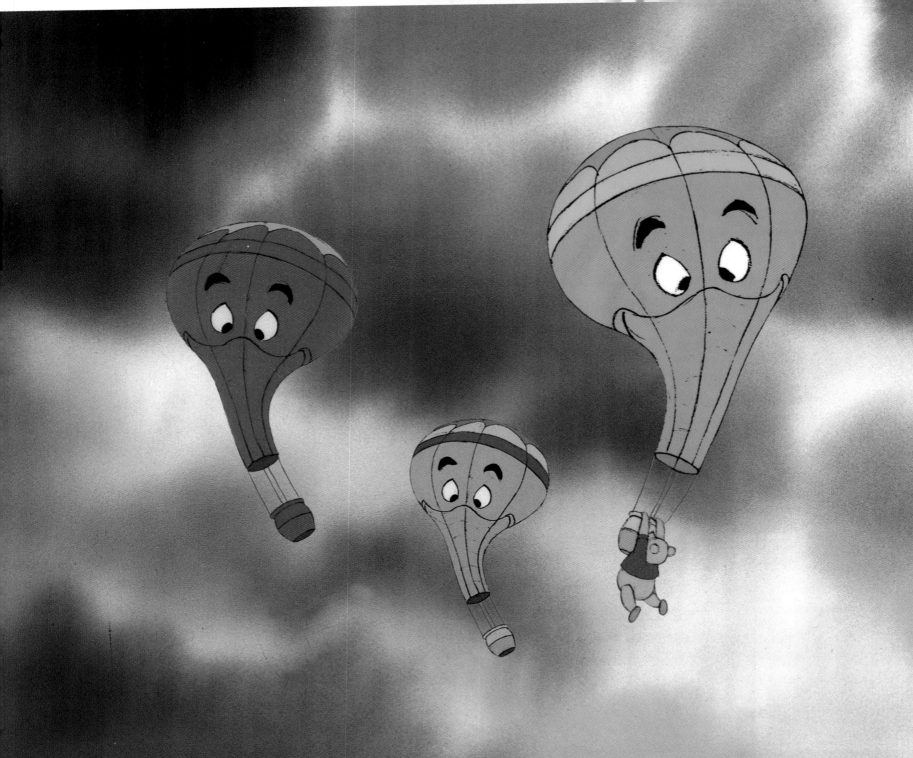

NARRATOR: "It was raining all over the Hundred-Acre Wood. There was a thunderstorm on page seventy-one—and on page seventy-three there was a bit of cloudburst."

BELOW: *Piglet is swept away by the water. Cel setup from Scene 306.*

RIGHT: *Pooh rescues supper from the flood. Storyboard art from Scene 145.*

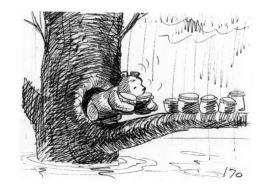

122

LEFT: *Owl is too busy talking to notice the coming waterfall. Cel from Scene 310.*

RIGHT: *Piglet struggles desperately to avoid going over the waterfall. Cel setup from Scene 311.*

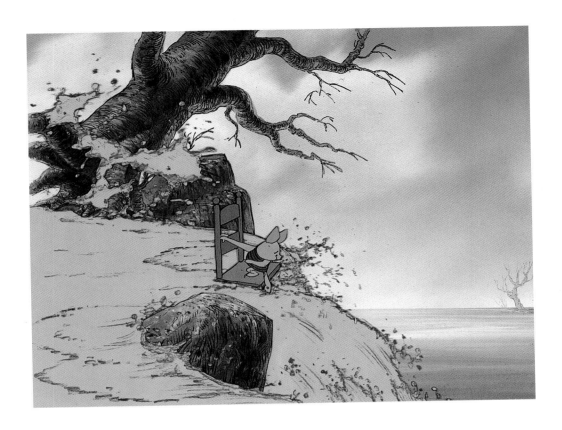

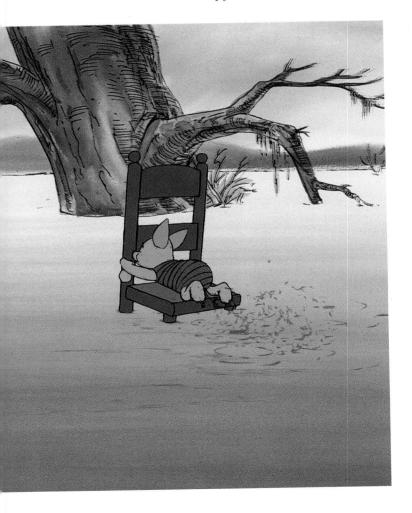

PIGLET: **"We're coming to a flutterfall, a flatterfall, ah, ah, wa-wa—a very big waterfall!"**

OWL: **"Please, no interruptions."**

CHRISTOPHER ROBIN: **"Pooh, you rescued Piglet!"**

POOH: **"I did?"**

ABOVE: *Pooh is surprised
to be considered a hero.
Cel setup from Scene 322.*

ABOVE: *Christopher
Robin retrieves Piglet. Cel
setup from Scene 321.*

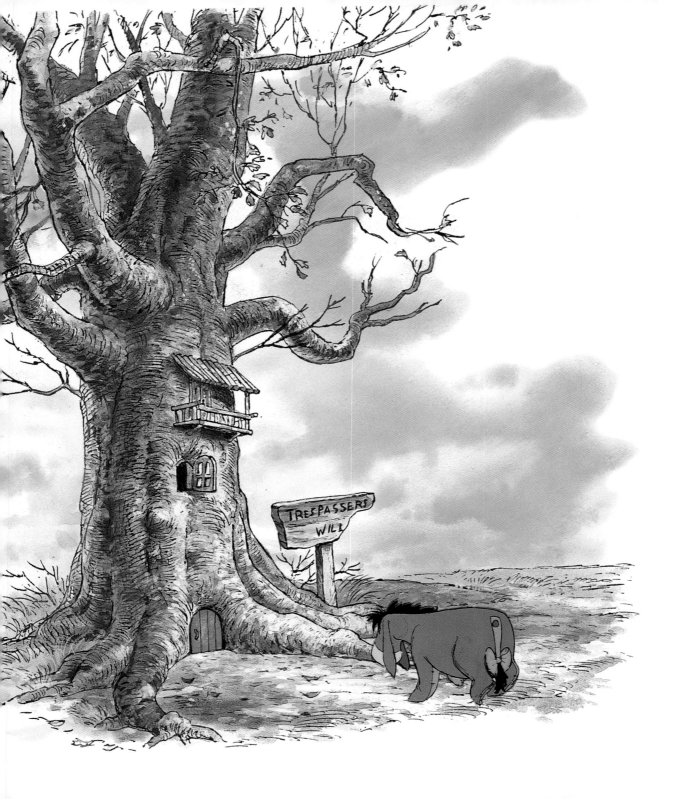

EEYORE: "I found it."

CHRISTOPHER ROBIN:

"Found what, Eeyore?"

EEYORE: "House for Owl."

ABOVE & LEFT:
Animation Cel.
The persistent Eeyore
announces that he has
found a new home for
Owl. Unfortunately it is
Piglet's house. Cel and
cel setup from Scenes
405 and 410.

POOH: "Tell them it's your house, Piglet."

PIGLET: "No, Pooh, this house belongs to our good friend (gulp), Owl."

RABBIT: "But Piglet, where will you live?"

PIGLET: "Well, I (sniff) I-I-I guess I shall live-ah (sniff) I-I-I suppose I—I shall live . . ."

POOH: "With me. You shall live with me, won't you, Piglet?"

THIS PAGE: *Piglet bravely offers his house to Owl and is then comforted by Pooh. Cels from Scenes 415 to 427.*

OPPOSITE: *Everyone gathers for a celebration party. Scene 430.*

WINNIE THE POOH AND TIGGER TOO

It's a sunny morning in the Hundred-Acre Wood and Winnie the Pooh is sitting on a comfortable log in his Thoughtful Spot. While trying very hard to think of something to think about, he is bounced by Tigger. Tigger pauses briefly to re-introduce himself, then immediately takes his leave, explaining that he has lots of bouncing to do.

Tigger's next encounter is with Piglet, who is promptly bounced. Less substantial than Pooh, Piglet seems in danger of being crushed. Being plucky, however, he deals bravely with the situation and Tigger moves on, looking for other victims. To his delight he spots "Old Long Ears"—otherwise known as Rabbit—busy in his garden. Tigger takes a special pleasure in bouncing Rabbit because it always causes him to become so distressed. Today is no exception. Tigger bounces Rabbit and Rabbit is outraged. Always reasonable, in his own self-interested way, Tigger points out, "But bouncing is what Tiggers do best." Then he bounces off, on his incredible jumping-jack tail, singing his "Wonderful Thing about Tiggers" song.

Rabbit calls a meeting. Something, he insists, must be done about Tigger. Piglet and Pooh are the only members of Rabbit's audience, and Pooh soon falls asleep, but a scheme is hatched. According to Rabbit's proposal, Tigger must be taken on a long "explore" and lost.

128

Needless to say, Tigger is all for a long exploration, and on a damp, foggy day, when trees look like ghosts, Piglet and Pooh join Rabbit and Tigger for an expedition to the heart of the Hundred-Acre Wood. Tigger is soon far ahead of everyone else, his enthusiasm and fast bouncing causing him to lose contact with the others. Seizing the opportunity, Rabbit urges Piglet and Pooh to hide with him in a hollow log. Tigger comes back to look for them. Not seeing "the blokes" anywhere, he bounces off into the mist.

Rabbit is thrilled. Convinced that they are rid of Tigger forever, he emerges from the log and, with Piglet and Pooh, sets off for home. The fog is becoming thicker by the minute, but Rabbit informs his companions that he knows the wood like the back of his paw. Despite this assurance, the trio is soon lost and going round in circles, passing the same sand pit over and over again, which prompts Pooh to suggest that if they set out for the sand pit they would soon arrive at home. Rabbit is not impressed by this sparkling display of logic and decides to strike out on his own. Piglet and Pooh allow themselves to be guided by the geographically trustworthy gurglings of Pooh's hungry tummy and are soon safely en route to his honey cupboard. When they are bounced by Tigger, who has long since found his way home, they inform him that Rabbit is still lost in the wood. Confidently telling them he will find Rabbit, Tigger bounces off.

Rabbit meanwhile becomes more and more lost. Night falls and he is terrified, imagining that frogs and even caterpillars are lurking monsters. Just as his terror reaches a crescendo, he is bounced by Tigger. To Rabbit's embarrassment, his striped

tormentor announces that Tiggers never get lost, places his tail in Rabbit's hands, and bounces him home.

A short while after this adventure, it begins to snow in the Hundred-Acre Wood. Soon the landscape is white and the rivers and ponds are covered with ice. Tigger has made a plan to take Roo bouncing. (Being a Kangaroo, Roo is a promising student.) They find a frozen pond and Tigger insists on skating. Almost immediately he loses control and skids helplessly into Rabbit, who has been performing effortless figures of eight.

The collision convinces Tigger that Tiggers do not like skating. What they do like, he tells Roo—and what they do best—is climbing trees. Actually, he corrects himself, they bounce trees, and to prove his point he bounces to the top of a very tall tree. Once up there, however, he makes the unpleasant discovery that Tiggers don't like heights. As for Roo, he has reached the lower branches of the same tree and, though perfectly happy, has no idea how to bring Tigger down.

As so often happens, Pooh and Piglet are nearby. They follow two sets of footprints in the snow—footprints that converge and criss-cross—and get thoroughly muddled up. It does not occur to them that once again they might be going round and round in circles, that the footprints they are following might be their very own. Rather, they come to the conclusion that the mysterious prints must have been made by some fierce creature such as a "jagular."

If you look up, Pooh warns, the jagular will drop on you.

Finally they do look up and see Roo and Tigger in the tree, the former swinging happily from a bough, the latter holding on for dear life and begging for Christopher Robin's help.

Christopher Robin arrives with the rest of the gang. Rabbit is thrilled to discover Tigger in his present predicament and wants to leave him there. The others are more sympathetic. Christopher Robin removes his coat and the animals help him hold it under the tree like a fireman's safety blanket. Roo jumps into the improvised blanket. Then comes Tigger's turn, but he's afraid to jump. He is so terrified, in fact, that he promises never to bounce again if someone will help him down.

At this point, the narrator comes to his rescue, tipping the tree on screen so that Tigger is able to climb gingerly from the branches to the soft snow beneath.

"I'm so happy," he says, "I could bounce!"

Then he realizes he has promised never to bounce again. Depressed, he slinks off into the snowdrifts. Rabbit is beside himself with joy. Roo, however, says he liked the bouncy Tigger better, and except for Rabbit, everyone agrees. Finally Rabbit submits to peer pressure, admitting that an unbounced Tigger is not pleasant to contemplate.

Overjoyed, Tigger returns to the little group, and everyone celebrates by bouncing along with him through the enchanted landscape of the Hundred-Acre Wood.

THE FILMS ARE PRESENTED: WINNIE THE POOH AND TIGGER TOO

TIGGER: "Hello Pooh! G-rrrr
... I'm Tigger! T-I-
double Guh-er! That spells
'Tigger'!"

POOH: "Ye-ah, ah-h, I know....
You've bounced me before."

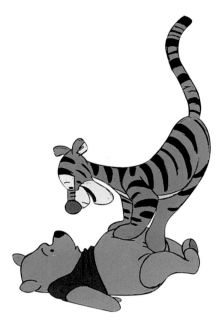

TIGGER: "I did? Oh yeah ... I
re-eh-coginize you....You're
the one who's stuffed with
fluff!"

POOH: "Eh, yeah ... and you're
sitting on it!"

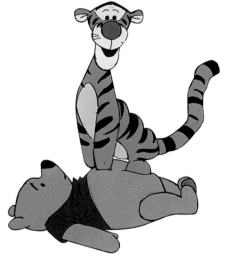

THIS PAGE &
OPPOSITE: *Tigger*
bounces Pooh—again.
Cel setups from Scene 3.

133

TIGGER: "Hello Rabbit!
I'm Tigger! T-I-
double-guh . . ."

RABBIT: "Oh . . . Pah . . .
Please . . . Please don't
spell it! Oh dear . . .
oh . . . eh . . . j-just . . .
j-just . . . look at my
beautiful garden!"

TIGGER: "Ye . . . yeeech . . .
messy, isn't it?"

134

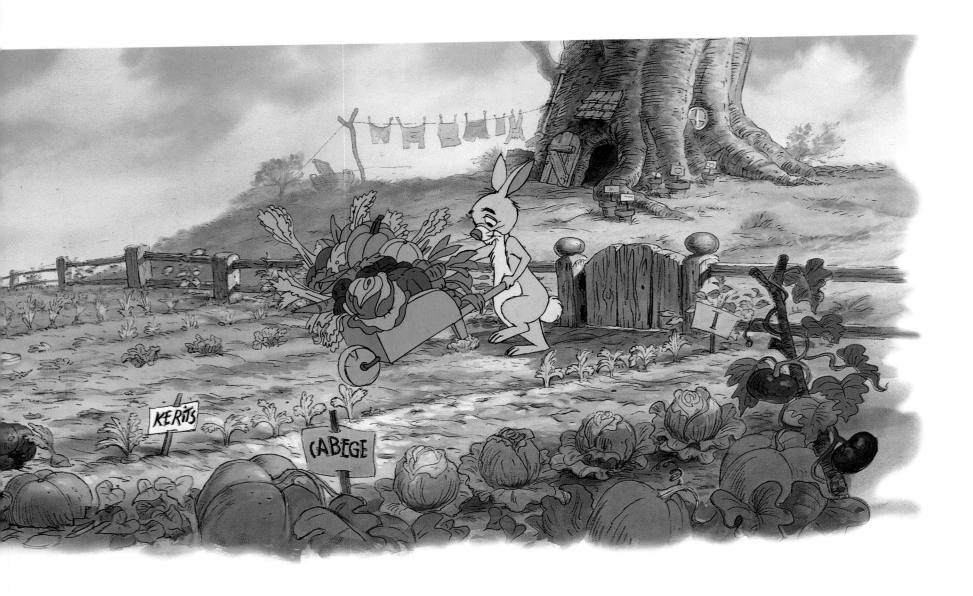

THIS PAGE & OPPOSITE: *Tigger bounces through*

Rabbit's beautiful garden *it. Scenes 19 and 28.*

becomes a mess after

PIGLET: "Pooh, we were just trying to think of a way to get the bounce out of Tigger."

RABBIT: ". . . we'll take Tigger for a long explore."

LEFT & ABOVE: *Rabbit conducts a meeting in order to solve the Tigger problem, but Pooh is inattentive. Rough animation and cel setups from Scene 51.*

TIGGER: "Hey, you blokes, where are you?"

POOH: "Ah . . . mm . . . h . . ."

RABBIT: "Shush!"

POOH: "I am shushed!"

ABOVE: *Rabbit, Pooh, and Piglet lead Tigger into the woods in order to lose him. Cel setup from Scene 70.*

RIGHT: *Rabbit, Pooh, and Piglet hide from Tigger in a log. Cel setup from Scene 90.*

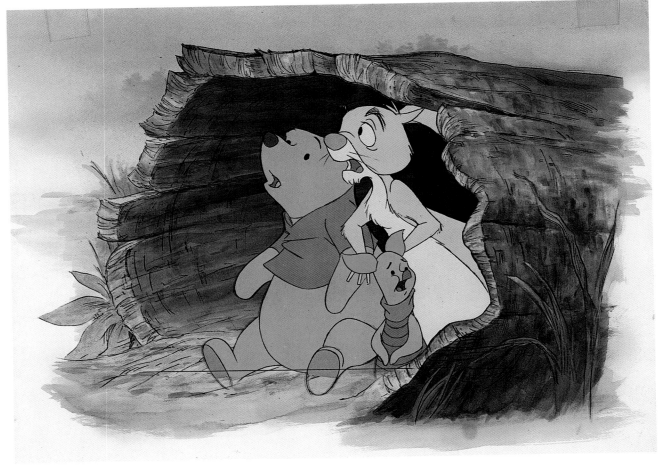

138

POOH: "Eh . . . say Rabbit, how would it be if as soon as we're out of sight of this old pit we just try to find it again?"

RABBIT: "What's the good of that?"

POOH: "Well y'see, we keep looking for home, but we keep finding this pit. So I just thought if we looked for this pit . . . ah . . . we might find home."

THIS PAGE: *Pooh and Piglet wait for Rabbit to prove that he can find them again. Animation from Scene 128 by Art Stevens.*

OPPOSITE: *Pooh, Piglet, and Rabbit become lost themselves in the Hundred-Acre Wood. Concept art.*

RABBIT: "Er . . . what's that? Pooh . . . Piglet . . ."

THESE PAGES:

Separated from Pooh and Piglet, Rabbit is lost, alone, and terrified. Storyboard art and cel setup from Scene 162.

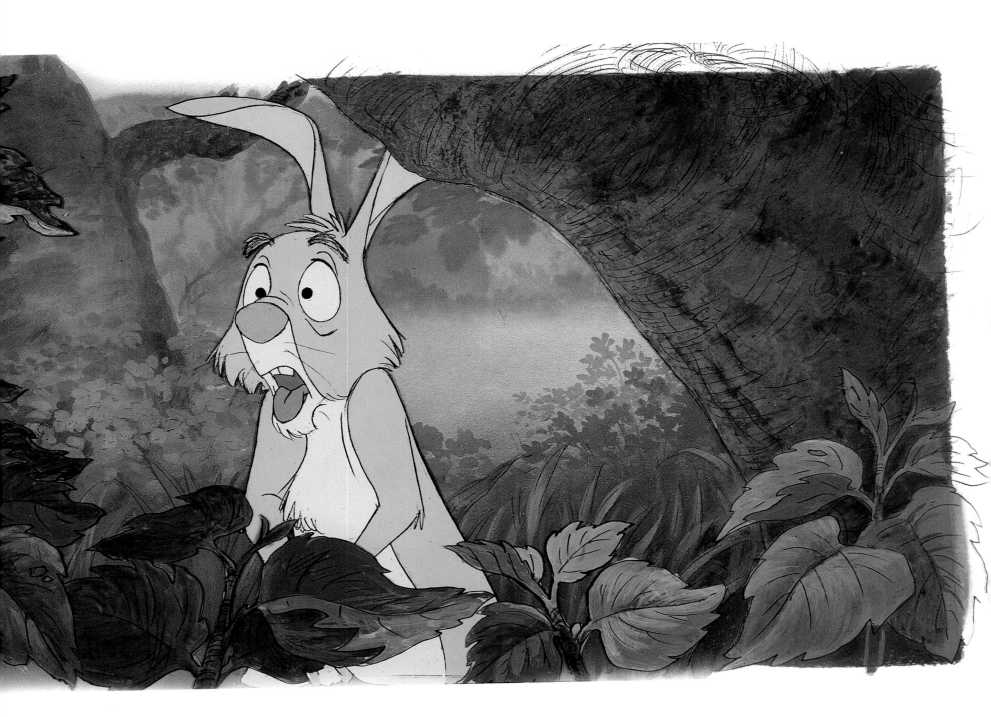

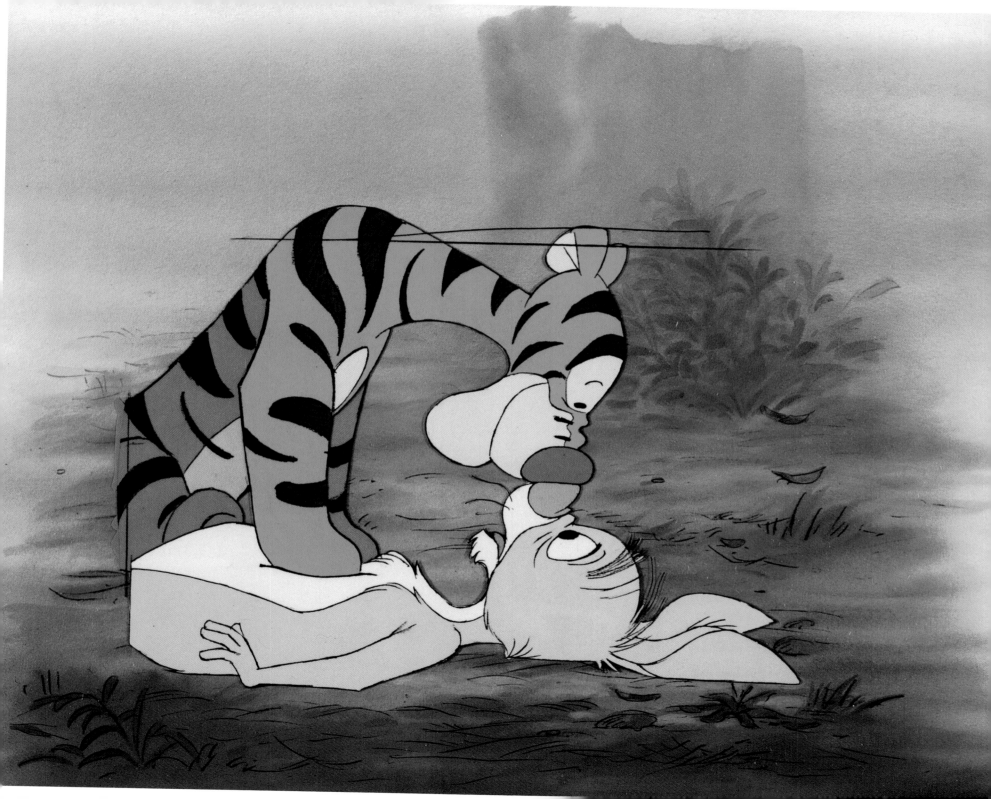

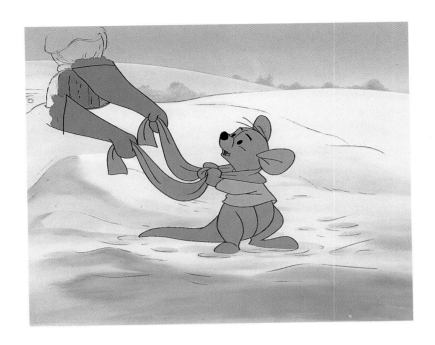

KANGA: "Goodness, you're bouncy today."

ROO: "That's what Roos do bestest!"

KANGA: "Oh-h, . . . now keep your scarf on."

ROO: "Not so tight, Mama."

KANGA: "Is your sweater warm enough?"

ROO: "Yes, mother!!"

ABOVE: *Kanga bundles up Roo for a day of adventure with Tigger. Cel setup from Scene 217.*

RIGHT: *Tigger slips on the ice while showing off for Roo. Rough animation from Scene 238 by Milt Kahl.*

OPPOSITE: *An embarrassed Rabbit is eventually found and bounced again by Tigger. Cel setup from Scene 191.*

ROO: "I bet you could climb trees."

TIGGER: "Ah . . . climb trees!" Ha, ha, ha, hooo, ah . . . that's what Tiggers do best!
Only Tiggers don't climb trees . . . they bounce 'em."

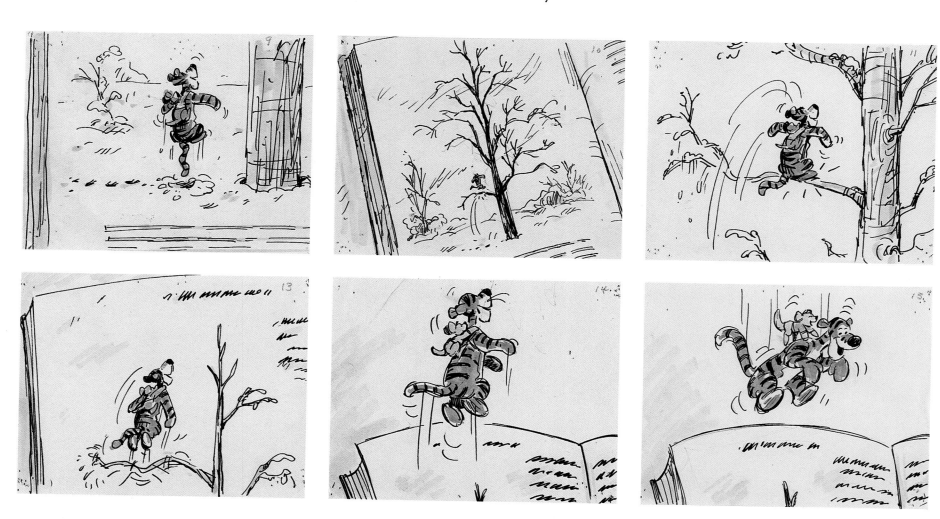

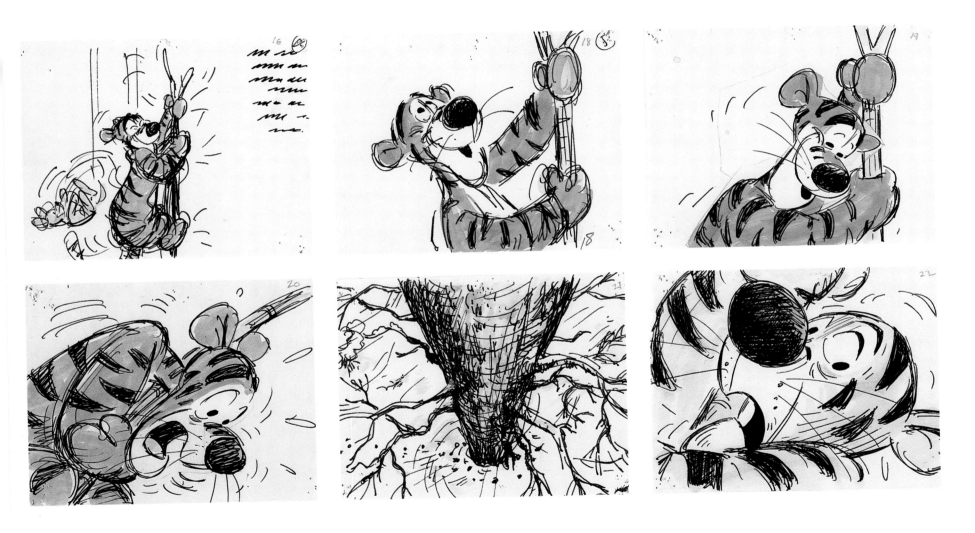

THESE PAGES: *Tigger* *discovers how high he is.* *bounces up a tree and* *Storyboard art from* *is terrified when he* *Scenes 296 to 302.*

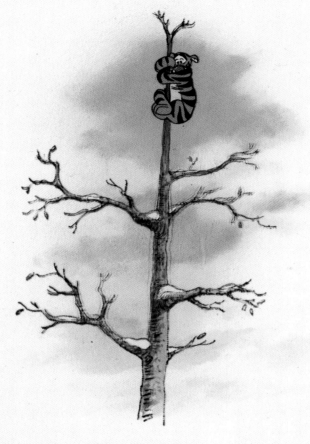

Well,
we'll
just
have
to
leave
Tigger
up
in
the
tree
top
for
a
little
while.

Whether he would have bounced any higher, I don't know, but just as he had got to the top, little Roo cried, "We're going to stay here for ever and ever unless we go higher. What do you say, Tigger?"

"Hunting," said Pooh.

"Hunting what?"

"Tracking something," said Winnie-the-Pooh very mysteriously.

"Tracking what?" said Piglet, coming closer.

"What do you see there, Piglet?"

"Tracks," said Piglet. "Paw-marks." He gave a little squeak of excitement. "Oh, Pooh! Do you think it's a—a—a Woozle?"

"It may be," said Pooh. "Sometimes it is, and sometimes it isn't. You never can tell with paw-marks."

There was a small spinney of larch trees just here, and round this spinney went Pooh.

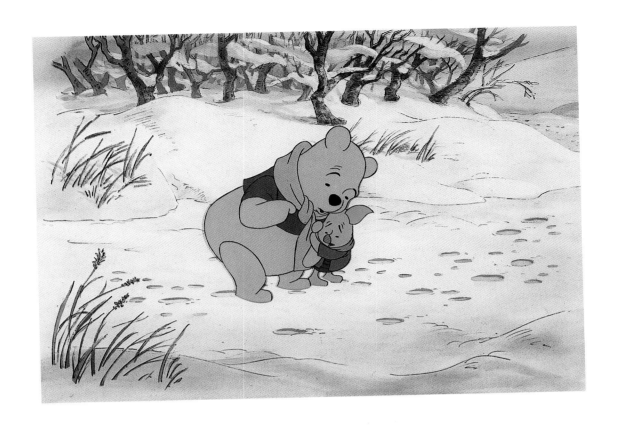

OPPOSITE & RIGHT:

While Tigger is stuck

up a tree, Pooh and

Piglet puzzle over

some mysterious tracks.

Cel setups from

Scenes 350 and 358.

PIGLET: **"What ya doing, Pooh?"**

POOH: **"Sh . . . tracking something."**

PIGLET: **"Tracking what?"**

POOH: **"Well, that's what I ask myself, Piglet . . . what."**

PIGLET: **"And what-a ya think you'll answer yourself?"**

POOH: **"Oh, I shall have to wait until I catch up with it."**

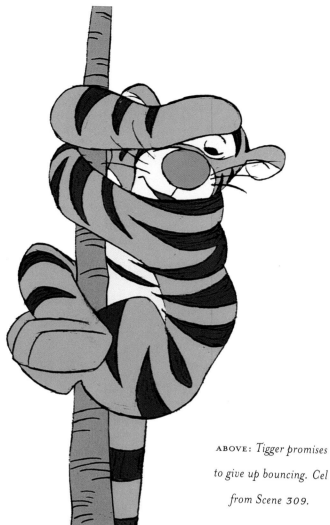

TIGGER: "Oh, if I ever get outa dis . . . I promise never ta bounce again . . . ah . . . never!"

RABBIT: "I heard that, Tigger . . . he promised! Did you hear him promise? I heard him . . . I heard him!"

ABOVE: *Tigger promises to give up bouncing. Cel from Scene 309.*

RIGHT: *Rabbit is excited by the thought of a bounceless Tigger. Cel setup from Scene 424.*

148

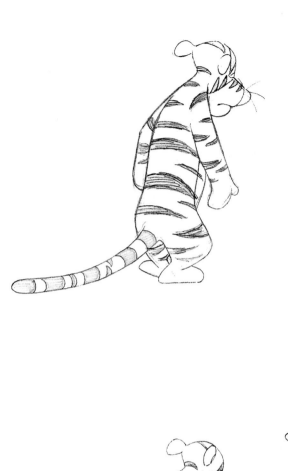

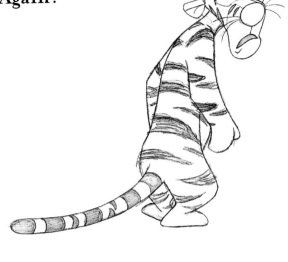

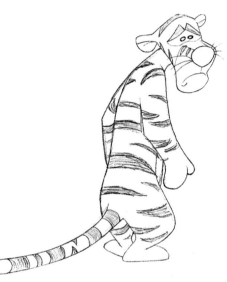

THIS PAGE: *Rescued from the top of the tree, a dejected Tigger realizes that he has promised never to bounce again. Animation from Scene 510 by John Pomeroy.*

TIGGER: "Ya mean I can have my bounce back . . . ?
Wh-ha, ha, ha, ha, . . . whoo! . . . Ah . . . come on
Rabbit! Let's you and me bounce, huh?"

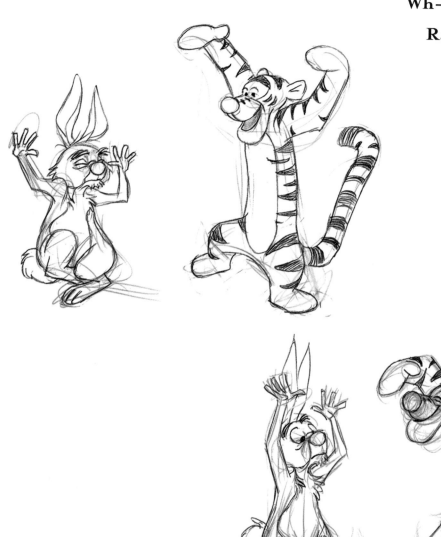

150

THESE PAGES: *After deciding that a bouncy Tigger is better than an unhappy Tigger, everyone follows him in a bouncing celebration. Rough animation and cel setup from Scenes 534 and 537.1 by Cliff Nordberg and Art Stevens.*

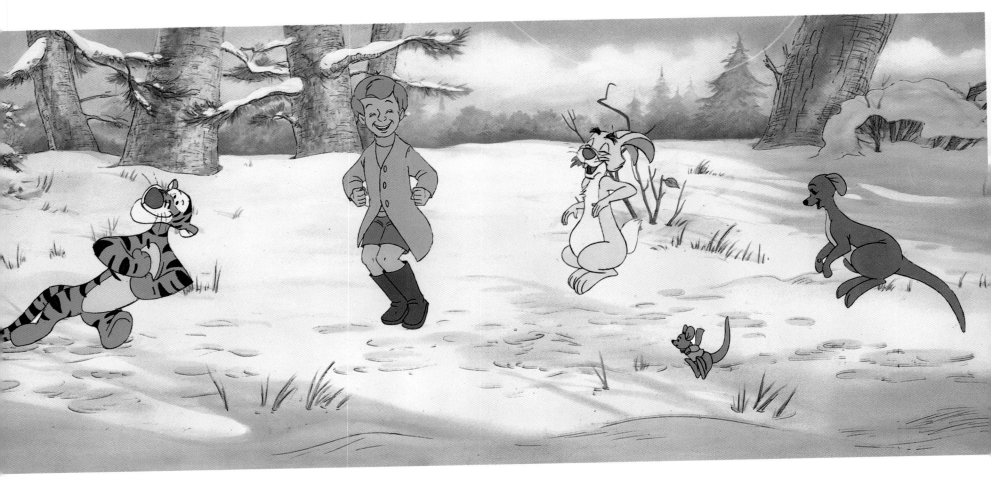

WINNIE THE POOH AND A DAY FOR EEYORE

On a beautiful day on a lovely old bridge over a peaceful little river in the Hundred-Acre Wood, Winnie the Pooh accidentally invents a game that he calls Pooh Sticks. This is how it's played: contestants throw sticks into the water from the upstream side of the bridge. Then they scamper to the downstream side to see whose stick emerges first. The owner of that stick is the winner. As they play the game one time, Pooh, Piglet, Rabbit, and Roo notice an unusual stick floating by. It is big and gray and it doesn't belong to any of them. In fact, it isn't a stick at all—it's Eeyore's tail. What's more, Eeyore is attached to it.

A rescue operation is set into motion. At first it doesn't go too well, since Pooh almost succeeds in drowning Eeyore by hitting him with a large boulder. Finally Eeyore comes ashore and explains that he fell into the river after being bounced by Tigger—a charge that Tigger later denies, claiming that he just so happened to have coughed rather vigorously while in Eeyore's general vicinity.

Eeyore goes on to mention that he is depressed anyway, even more so than usual, because it's his birthday and nobody has given him a present. Everyone feels bad about

this. Pooh heads for home to fetch a pot of honey. On his way to Eeyore's house, however, the exertion of the journey makes him hungry, so he eats the honey. Luckily, Pooh's modest brain is working at optimum efficiency. An empty pot, he realizes, is perfect for putting things into. With this practical thought in mind, he offers the pot to Eeyore.

Unfortunately, Eeyore has nothing to put in it. Nothing, that is, till Piglet arrives with a balloon he has been saving for just such an emergency. The balloon has been punctured and torn to shreds during the course of its journey to Eeyore's house, but Eeyore does not see this as a drawback. On the contrary, he is delighted, since an inflated balloon would not have fit into the pot whereas a tattered balloon fits perfectly.

A birthday party is thrown for the morose little donkey. When Tigger shows up, Rabbit argues that he should be barred from the festivities for having bounced Eeyore into the river. Christopher Robin distracts everyone from the argument by suggesting that they go to the river for another game of Pooh Sticks.

At first, everything goes well. Eeyore wins more games than anyone else. Tigger doesn't win at all and stalks off in frustration, his head down, his demeanor bounceless. Feeling sorry for Tigger, Eeyore follows him and offers the secret of winning at Pooh Sticks. (It's all a matter of dropping the stick into the river in a special twitchy sort of way.) Tigger is thrilled with this information and his bounce is restored.

POOH: "That's funny. I dropped it on the other side and it came out on this side. I wonder if it would do it again. I wonder which would come first."

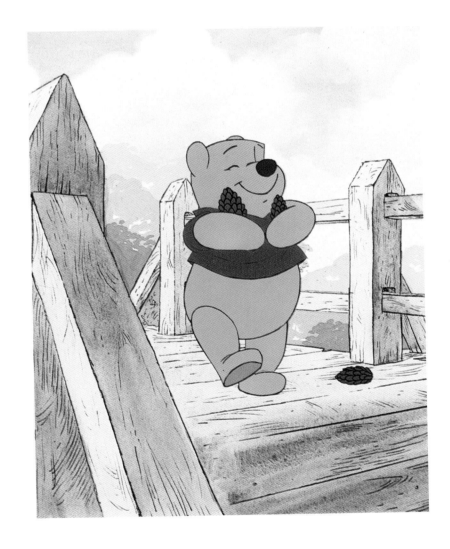

ABOVE & RIGHT: *Pooh gathers pine cones to drop over the side of the bridge. Cel setups.*

OPPOSITE: *In the most peaceful spot of the Hundred-Acre Wood was an old wooden bridge. Cel setup.*

EVERYONE: "It's . . . it's . . . Eeyore!"

EEYORE: "Don't pay any attention to me. Nobody ever does."

OPPOSITE: *Pooh and his friends are playing Pooh Sticks when they see something strange floating in the river. Cel setup.*

THIS PAGE: *Eeyore awaits help after being bounced into the river by Tigger. Cels.*

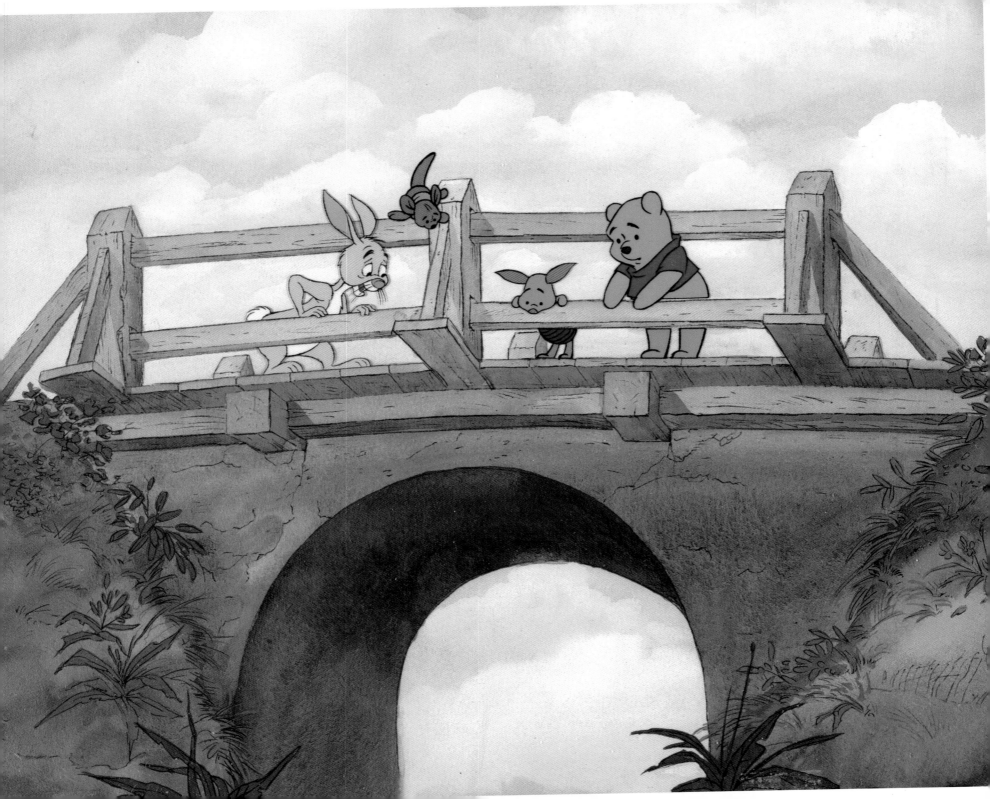

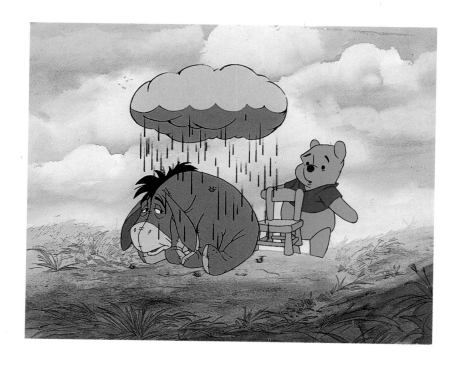

ABOVE & LEFT: *Eeyore is gloomier than usual with no presents, no candles, and no cake on his birthday. Storyboard art and cel setup.*

BELOW: *Pooh decides to give Eeyore a jar of honey but absentmindedly eats the gift. Cel setup.*

POOH: "Eeyore, what's the matter? . . . You seem so sad."

EEYORE: "Why should I be sad? It's my birth-day. The happiest day of the year."

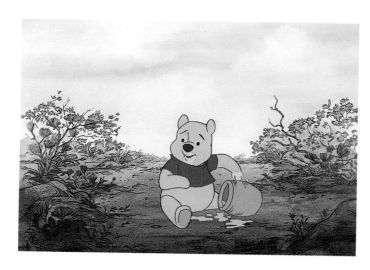

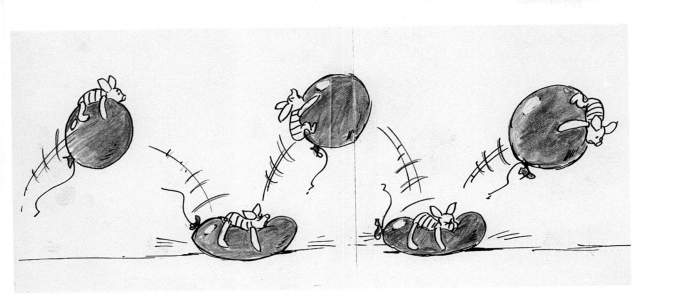

THIS PAGE: *Piglet decides to give a balloon as a present but has an accident on the way to Eeyore's. Storyboard art and cels.*

PIGLET: "Oh d-d-dear. What shall I . . . ? How shall I . . . ?
Well, perhaps Eeyore doesn't like balloons so very

 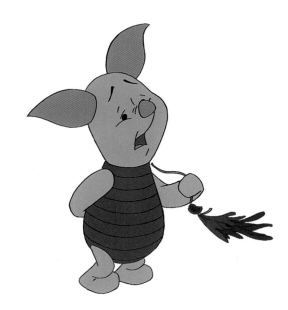

POOH: "Eeyore, I'm very glad I thought of giving you a useful pot to put things in."

PIGLET: "And I'm very glad I thought of giving you something to put in a useful p . . . p . . . pot."

ABOVE: *Eeyore discovers that a popped balloon fits perfectly into an empty pot. Cels.*

RIGHT: *Pooh and Piglet are happy that their gifts have been well received. Cel setup.*

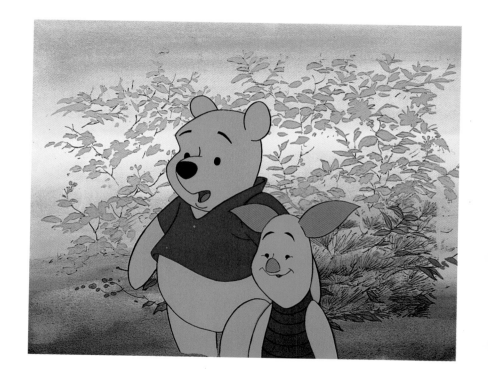

OPPOSITE: *Eeyore finally smiles from the attention he receives. Cel setup.*

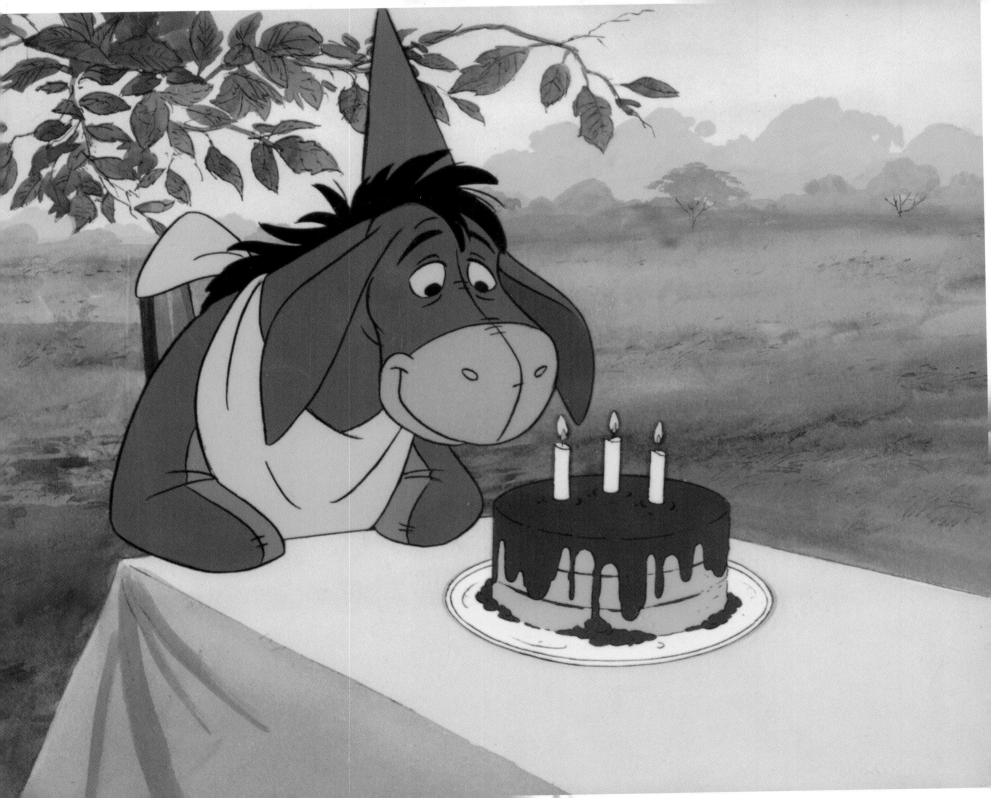

CHAPTER FIVE

In Which

The Popularity of Pooh Continues

SINCE HIS LITERARY DEBUT IN 1926 and his film debut in 1966, Winnie the Pooh has become the most famous and beloved bear in the world. His life beyond the Milne stories and the Disney featurettes based upon them has proved to be a long and healthy one. In 1981 *The Many Adventures of Winnie the Pooh* was released on video and has enjoyed huge popularity. That same year an educational film, *Winnie the Pooh Discovers the Seasons*, was released. This was the first of four teaching films featuring Pooh and his friends. In 1982 a show entitled *Winnie the Pooh and Friends*, featuring clips from the existing Pooh films along with footage from other Disney animated movies, was broadcast on television. Then in 1983, just a few weeks after the theatrical release of *Winnie the Pooh and a Day for Eeyore*, the studio launched a television series called *Welcome to Pooh Corner* on the Disney Channel. The characters were brought to life via "puppetronics"—life-sized costumes articulated by actors and electronics. The episodes imparted value-laden messages such as "truth will out" and "a friend in need is a friend indeed."

OPPOSITE: *Sitting in front of his home, the famous Pooh Bear acknowledges his audience. Cel setup from Scene 5 of* Winnie the Pooh and the Honey Tree.

ABOVE: *Christopher Robin and the gang cross a river. Production Still from* Pooh's Grand Adventure, the Search for Christopher Robin.

The New Adventures of Winnie the Pooh, an animated television series, was launched on the Disney Channel in January of 1988, switching to ABC later that year. The scripts in the series were not directly based on Milne material but made an honorable effort not to stray too far from the spirit of the Pooh books. With an animation quality much better than the usual television fare, and solid voice talents, *The New Adventures of Winnie the Pooh* won an Emmy Award for Best Animated Program, Daytime, in both 1989 and 1990.

Starting in 1991, Pooh continued to appear on television in a series of holiday specials: *Winnie the Pooh and Christmas Too; Boo! To You Too; A Winnie the Pooh*

Thanksgiving; and *Winnie the Pooh, A Valentine for You.* More are under development.

In 1997 the studio issued a full-length home video feature entitled *Pooh's Grand Adventure: The Search for Christopher Robin.* The critically acclaimed movie takes off from the point at which Milne and *The Many Adventures of Winnie the Pooh* ended. Christopher Robin has left for school. The denizens of the Hundred-Acre Wood manage to misunderstand this and think he has gone to "Skull," which sounds pretty sinister. They are so concerned, in fact, that they set out to rescue him from whatever dangers he's fallen into. Needless to say, this leads Pooh, Piglet, Tigger, and the rest into all kinds of adventures.

In February 2000, Tigger bounced onto the big screen in his very own full-length feature: *The Tigger Movie.* The film focuses on the ordinarily happy-go-lucky

Tigger who comes to realize that being the onliest tigger may also mean being the loneliest tigger. Thus begins the search, high and low, near and far, across the Hundred-Acre Wood for Tigger's family. Pooh, Piglet, Eeyore, Owl, Kanga, and Roo all join the hunt. Yet, in the end, Tigger realizes that his family is made up of his pals from the Hundred-Acre Wood. His real family had been right beside him all along.

In addition to their success on the screen, Pooh and his friends have proliferated in other forms. The public's hunger for Pooh likenesses and Pooh paraphernalia seems to be insatiable. Beside Milne's two Pooh books, there are now scores of publishing spin-offs ranging from comics to pop-up books, from cookbooks to "how to draw Pooh" books.

Early peripheral products included various Pooh and Christopher Robin calendars and *The Christopher Robin Birthday Book*. Pooh paper-doll books were produced as early as the 1920s, and other prewar collectibles include various ceramic items, including bowls and pitchers, jigsaw puzzles, and at least a couple of board games. Now it is possible to buy Pooh Christmas ornaments, Pooh pile rugs, Pooh backpacks, Pooh cookie cutters, and Pooh towel pegs. Nor are his friends forgotten. There are Tigger jogging pants, Piglet baseball caps, Eeyore bookends, and Christopher Robin mugs.

But Pooh and most of his friends began life as toys, and at the heart of the passion for Pooh collectibles are, appropriately, the toys themselves. As noted in chapter one, Christopher Robin's Pooh was an Alpha made by J. K. Farnell, and the bear belonging to Ernest Shepard's son—the primary

BELOW: *Poster for* The Tigger Movie.

model for the drawings—was a Steiff from Germany. Given the success of the books, however, it was only a matter of time before teddies designated as Pooh bears were offered for sale. The British Teddy Toy Company brought out a Pooh series in the early thirties, and several other manufacturers soon followed their example. The production of Pooh bears was licensed in America as early as 1930.

Certainly the best-known pre-Disney Pooh soft toys, however, were those made by Agnes Brush and sold through F.A.O. Schwarz in the 1940s and 1950s. These are memorable because they are so distinctive. Brush's version of Pooh does not look very much like Pooh in the Shepard drawings. The proportions are totally different, as are details like the ears, while the bear's features consist of nothing more

than a flat black nose and shoe-button eyes. And then there is that red T-shirt. Brush's tan flannel Pooh is a Pooh that a child might make if he or she had the necessary manual dexterity. Of the remaining characters, Ms. Brush's cotton Piglet is quite wonderfully simplified, like a drawing by James Thurber. Owl also displays a Thurberish look, as does Tigger. Kanga and Roo are wittily constructed from rust and tan felt, while Rabbit, with painted eyes and string whiskers, is almost abstract in conception. Eeyore is the character who comes closest to Shepard's models, though he lacks the spirit of some of the others.

When Disney obtained marketing rights to Pooh in 1961, the company immediately entered into negotiations with the management of Sears stores, and it was agreed that the retailer would

offer a line of Pooh merchandise based on the Disney versions of the Milne characters. The Gund Manufacturing Company of New York, another long-time producer of teddy bears, made stuffed Pooh toys for Sears, as did Cal Toys of California. Gund also produced special versions for the Disney parks.

Recent Disney merchandise—including Gund's current line—is closely matched to the on-screen appearance of the characters, their authenticity being guaranteed by careful scrutiny on the part of the studio. Companies like Gabrielle Designs, in England, and Anne Wilkinson Designs, in America, have made handsome additions to the roster of Pooh soft toys.

The most famous recent entries into the field are the exquisitely crafted figures created by American doll artist R.

John Wright, beginning in 1985. Wright is the legitimate successor to Agnes Brush, producing much of his work for F.A.O. Schwarz, though he has also made Pooh toys for Disney outlets and for special events such as Disney conventions. Almost all of his work is issued in limited editions,

BELOW: *The citizens of the Hundred-Acre Wood. Dolls by John Wright.*

a few hundred to 3,500. His Milne characters are an interesting blend of Disney (under whose license they appear) and Shepard. His Pooh, in fact, is more Shepard than Disney, and all of the characters are reinterpreted through Wright's highly tuned sensibility. His masterpieces may be his two versions of Christopher Robin, which display a naturalism that is not typical of the Pooh canon. Naturalism, in fact, is Wright's strong point. If Agnes Brush's Milne figures were made for children but coveted by adults, Wright's are made for adults but coveted by children.

Fortunately there is something out there for everyone, from Wright's luxury dolls to the Pooh premiums offered at McDonald's and the Pooh postage stamps that have been issued in several countries. So many items—all inspired by a silly old bear.

HOW IS IT POSSIBLE for such a simple bear to achieve such greatness? What makes Pooh's world a world we all like to visit, as fresh today as it was in the 1920s? To answer these questions we must look first at A. A. Milne's place in the history of children's literature.

Nursery rhymes and fairy tales are almost as old as civilization, but they belong to folk tradition rather than to the field of children's literature. Texts intended specifically for children are a relatively recent phenomenon, and they reflect a radical shift in society's attitude toward the child. Until the 19th century at least, children tended to be regarded as small, unformed adults, and the assumption was that they would best be instructed by exposure to appropriate adult books—instruction being the entire purpose of reading so far as most parents and pedagogues were concerned.

Even as the beginnings of a children's literature emerged, though, in the middle of the 19th century, the emphasis remained on instruction, but a new concept of childhood was evolving in which the child was seen as passing through distinct phases of existence on the way to adulthood. This concept embraced the notion that children might actually benefit from entertainment, and even that their enjoyment might be rooted in a degree of anarchy. A classic early example of a response to these possibilities was *Edward Lear's Book of Nonsense* (1846), the first of several volumes he produced that introduced such memorable absurdities as "The Owl and the Pussycat" and "The Courtship of the Yongy-Bonghy-Bo." Soon after came Charles Kingsley's *The Water Babies* (1863), a fantasy that paid scant attention to instruction, and then Lewis Carroll's *Alice's Adventures in Wonderland* (1865), which combined fantasy and nonsense, and actually made fun of pedagogy.

The outpouring of children's books over the next half century in Britain and America was astonishing. The Pooh books fit right into the British wing of this tradition, but they differ from the rest—with the possible exception of Beatrix Potter's stories—in that they capitalize upon the imaginative tendencies of the very young. *Winnie-the-Pooh* and *The House at Pooh Corner* are substantial volumes—each about 150 pages—of continuous narrative conceived in terms of the thought processes of a four- or five-year-old, but with just enough adult perspective to provide a modicum of structure. Perhaps no other books have ever taken adults further back into the world of childhood. This may be the primary reason they were such a hit

when they first appeared, and why they remain so popular today. They bring us astonishingly close to what we like to think of as a state of innocence.

And if A. A. Milne fits right in with the tradition of children's literature, so does Walt Disney. If we look at the sources of his animated films, we encounter many of the British classics: *Alice in Wonderland*, *Peter Pan*, *The Wind in the Willows*, *The Jungle Book*. Single-handedly and memorably, Disney brought this whole tradition to the screen, contributing a Hollywood flair so that these great stories were absorbed into a unified Anglo-American tradition. The Pooh featurettes—for all the commercial pressure involved in their production—managed to preserve much of the

innocence that is found in the Milne books while introducing touches provided by animation that make the stories accessible to a wider audience.

Still, Milne's achievement is basic to our enjoyment of Pooh. Using his son as a kind of medium, he was able to will himself back to that moment when the faculty of logic is beginning to impinge on the imagination but has not yet

RIGHT: *Pooh and Piglet making tracks on the snow. Ernest H. Shepard illustration from page 37 of* Winnie-the-Pooh.

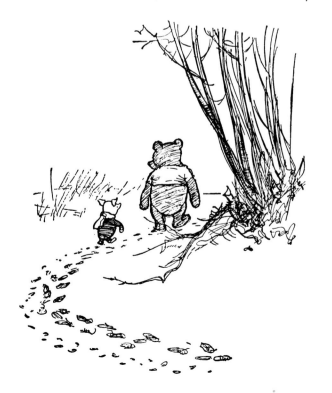

170

become an entirely reliable tool. For example, it is logical for Pooh to disguise himself as a rain cloud in order to fool the bees he plans to rob. Reason tells Pooh that they will not notice a blue balloon against a blue sky.

Another thing that makes Pooh's world so pleasant to enter and re-enter is its lack of malice. It might be thought that this is a characteristic of most children's books and movies, but in fact that is far from being the case. Most traditional fairy tales present battles of good against evil, as do classic children's stories as varied as *Black Beauty* and *The Adventures of Huckleberry Finn*. Similarly, the majority of the great Disney animated movies, even those that have no clear-cut villains, are structured around malicious schemes put into motion by larger-than-life villains.

The nearest thing to malice one encounters in the Pooh stories is Rabbit's scheme to have Tigger unbounced. And the closest one comes to tragedy is a minor natural disaster such as everyone being surrounded by water. The potential villains are all imaginary beings like Heffalumps and Woozles, and evil is something that has not yet penetrated the Hundred-Acre Wood. Yet this world is not boring, because the characters are subject to trials and tribulations. They lose their way. They lose their tails. They become wedged in rabbit holes. They are given baths by mistake. They are bounced by Tigger.

Never a dull moment.

The characters manage to stay busy while not doing very much of anything that the world would call important.

When he takes his last walk with Pooh, Christopher Robin says that what he likes best is doing nothing.

When Pooh asks, "How do you do nothing?" Christopher Robin explains with metaphysical precision:

> "Well, it's when people call out at you just as you're going off to do it, What are you going to do, Christopher Robin, and you say, Oh, nothing, and then you go and do it."

As we get older, it becomes harder and harder to do nothing in this profound and therapeutic sense. The Pooh books and films remind us of what doing nothing feels like and how much fun it can be. They also permit us to reinvent the tools that are required while doing nothing, tools such as creative indecision, vigorous hesitation, zestful indolence, and passionate inertia.

And central to the appeal of the Pooh stories is their silliness. When Christopher Robin says, as he often does, "Silly old bear!" it is the ultimate expression of affection. Silliness (with apologies to Tigger) is what small kids do best. Like "doing nothing," silliness can be a marvelous tonic, and the Pooh stories permit adults to tap once more into the world of childhood silliness and so refresh their imaginations.

Pooh lets us forget about rush hours, bills, and parking tickets. He is always waiting in the enchanted place, ready to take us back to a world where everything is still simple and we can do nothing.

It's what Poohs do best.

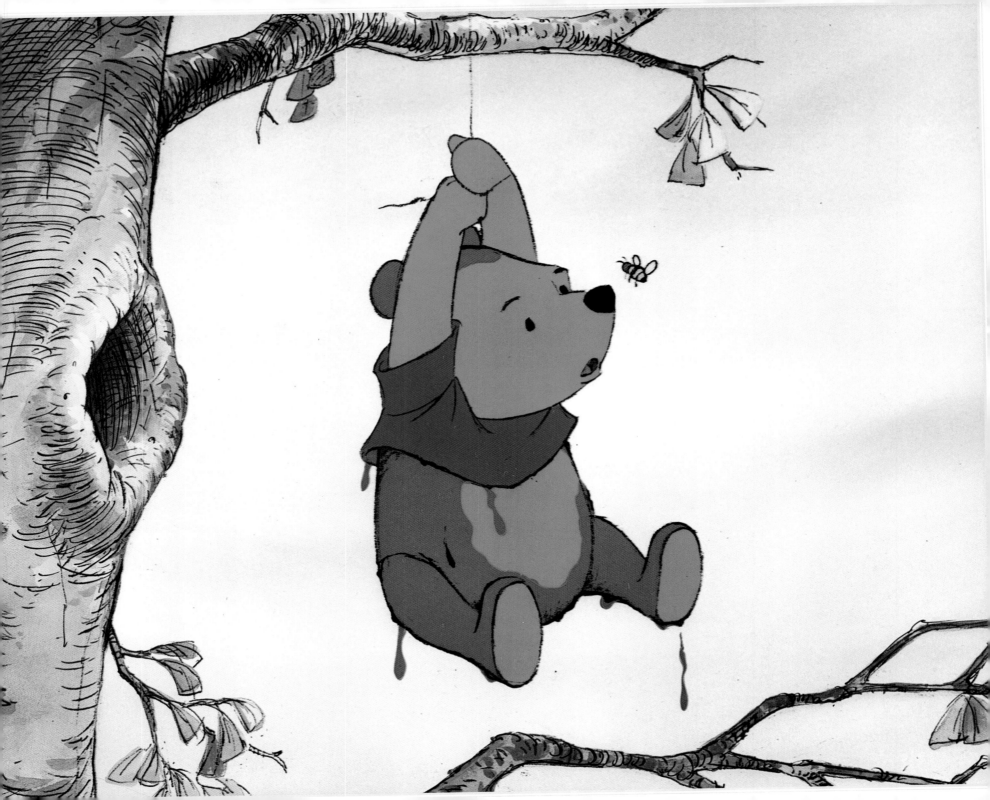

INDEX

FILM CREDITS

THE MANY ADVENTURES OF WINNIE THE POOH
(WINNIE THE POOH AND THE HONEY TREE, WINNIE THE POOH AND THE BLUSTERY DAY & WINNIE THE POOH AND TIGGER TOO)

STORY
Larry Clemmons
Ralph Wright
Vance Gerry
Xavier Atencio
Ken Anderson
Julius Svendsen
Ted Berman
Eric Cleworth

"BLUSTERY DAY"
SUPERVISION
Winston Hibler

PRODUCED BY
Wolfgang Reitherman

DIRECTED BY
Wolfgang Reitherman
John Lounsbery

MUSIC & LYRICS BY
Richard M. Sherman
Robert B. Sherman

SCORED & CONDUCTED BY
Buddy Baker

LAYOUT
Don Griffith
Basil Davidovich
Dale Barnhart
Joe Hale
Sylvia Roemer

BACKGROUND
Al Dempster
Art Riley
Bill Layne
Ann Guenther

ANIMATORS
Hal King
John Lounsbery
Milt Kahl
Frank Thomas
Ollie Johnston
Eric Cleworth
Art Stevens
John Sibley
Cliff Nordberg
Don Bluth
Eric Larson
Walt Stanchfield
Gary Goldman
Hal Ambro
Burny Mattinson
Dale Baer
John Pomeroy
Fred Hellmich

Chuck Williams
Bill Keil
Richard Sebast
Andrew Gaskill

PRODUCTION MANAGER
Don Duckwall

FILM EDITORS
Tom Acosta
James Melton

ASSISTANT DIRECTORS
Ed Hansen
Dan Alguire
Richard Rich

WINNIE THE POOH AND A DAY FOR EEYORE

PRODUCER AND DIRECTOR
Rick Reinert

STORY
Peter Young
Steve Hulett
Tony Marino

DIRECTING ANIMATORS
Ennis McNulty
Dave Bennett

ANIMATORS
Nancy Beiman

Irv Anderson
Tom Ray
Ken O'Brien
Virgil Ross
Lars Hult
Spencer Peel

KEY ASSISTANTS
Robert Shellhorn
Emily Jiuliano
Vera Lanpher
Sharon Murray
Philo Barnhart
Ayalen Garcia

CREATIVE TALENTS
Bev Chiara
Gretchen Heck
Sammie Lanham
Margaret Craig
Richard Williams
Allen Hohnroth
Kathi Castillo
Owen Gladden
Betty May Doyle
Pauline Weber
Judith Drake
Ted Bemiller

BACKGROUND
Rick Reinert
Dale Barnhart
Richard Foes

MUSIC
Steve Zuckerman

THEME MUSIC & LYRICS
Richard M. Sherman
Robert B. Sherman